STILLPOINT

*DANCE PHOTOGRAPHS
BY RONALD COMPTON*

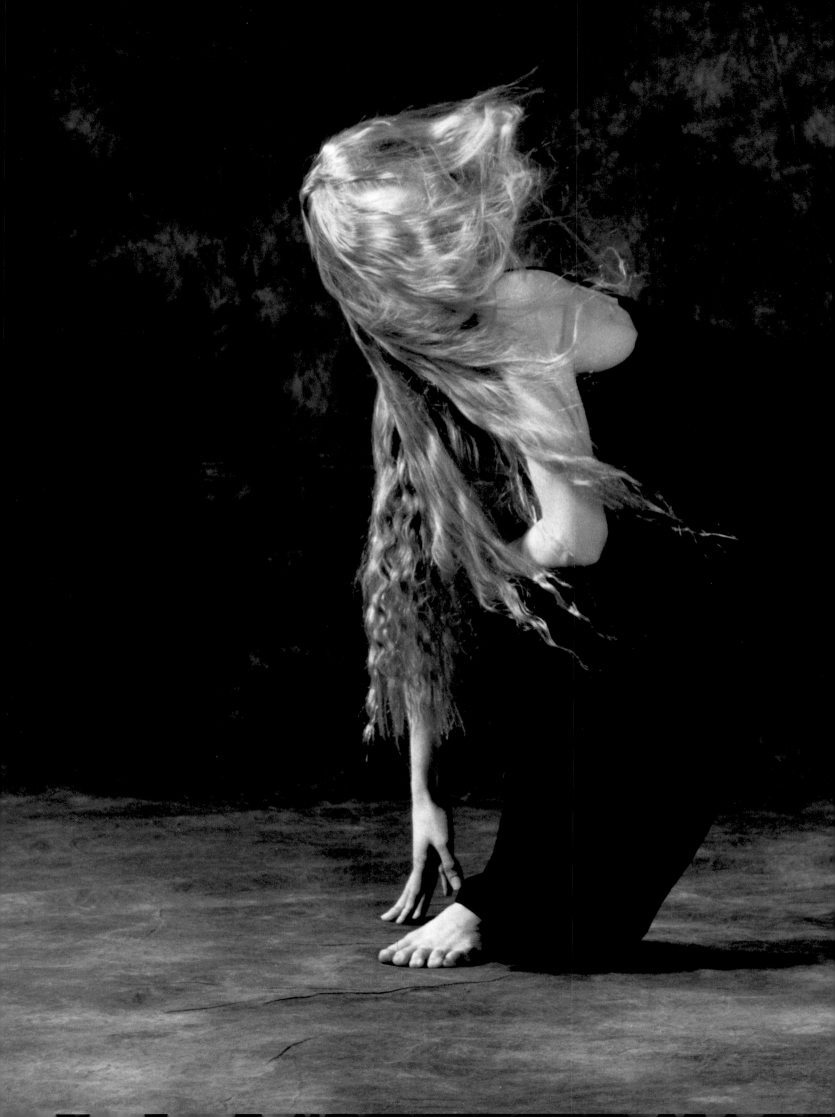

STILLPOINT

DANCE PHOTOGRAPHS
BY RONALD COMPTON

FOREWORD BY LARRY ALAN SMITH

INTERVIEW WITH RONALD COMPTON
AND ROBERT S. MILLER

AFTERWORD BY RALPH GIBSON

APERTURE

With love and gratitude
this book is dedicated
to my wife, Nancy,
who for more than
four decades has given
me love, support, and
understanding.

FOREWORD LARRY ALAN SMITH

It is perhaps the cruelest of callings. What often begins as a parental notion becomes a childhood ambition. There are dance recitals and Nutcrackers, and soon there are dreams of being a professional dancer.

Some quickly abandon these dreams once they realize how difficult and demanding the training will be. Others will see the dreams fade during adolescence as their bodies grow in unforgiving ways. Genetic factors become unyielding impediments, and even the most dynamic artistic sensibility cannot override the will of nature when it comes to the body of a dancer.

Only a few will have the physical, mental, and artistic gifts to train as serious artists. They will persevere and set goals that may or may not be realistic, but dancing is in their bodies and in their hearts. They dance despite the overwhelming odds that a career as a dancer will never materialize. Theirs

is a passion to be envied. It is a commitment that deserves to be applauded and supported, for their art can transport us beyond the mundane and bring us into contact with the very essence of beauty.

In direct and very tangible ways, Ron Compton has honored and improved the lives of dancers throughout his long and distinguished business career. He has used his influence to bring recognition and resources to the world of dance, enabling individuals and institutions to move forward. The cultural life of this country has been strengthened through his advocacy for the arts as a whole.

I find it particularly fitting that Ron's own artistry as a photographer is so closely linked to dance. The publication of this book is significant, and I feel privileged to contribute these few words. Ron's photographs are windows that allow us to see into the artistic souls of the dancers and the photographer. They capture the

movement, the moment, and the poetry of human communication. Regardless of the dancer or style of dance, unique and powerful images remain. They linger for our consideration and observation.

Dancers, musicians, actors, photographers and the like react to the voices within rather than the expectations of others. They do what they are able to do with the gifts that they are fortunate enough to possess. They work to develop these gifts, and they attempt to reflect the society in which they live. Artists have served as societal mirrors since the beginning of time, and it is through these individuals that the human spirit has evolved.

May parental notions and childhood ambitions continue forever!

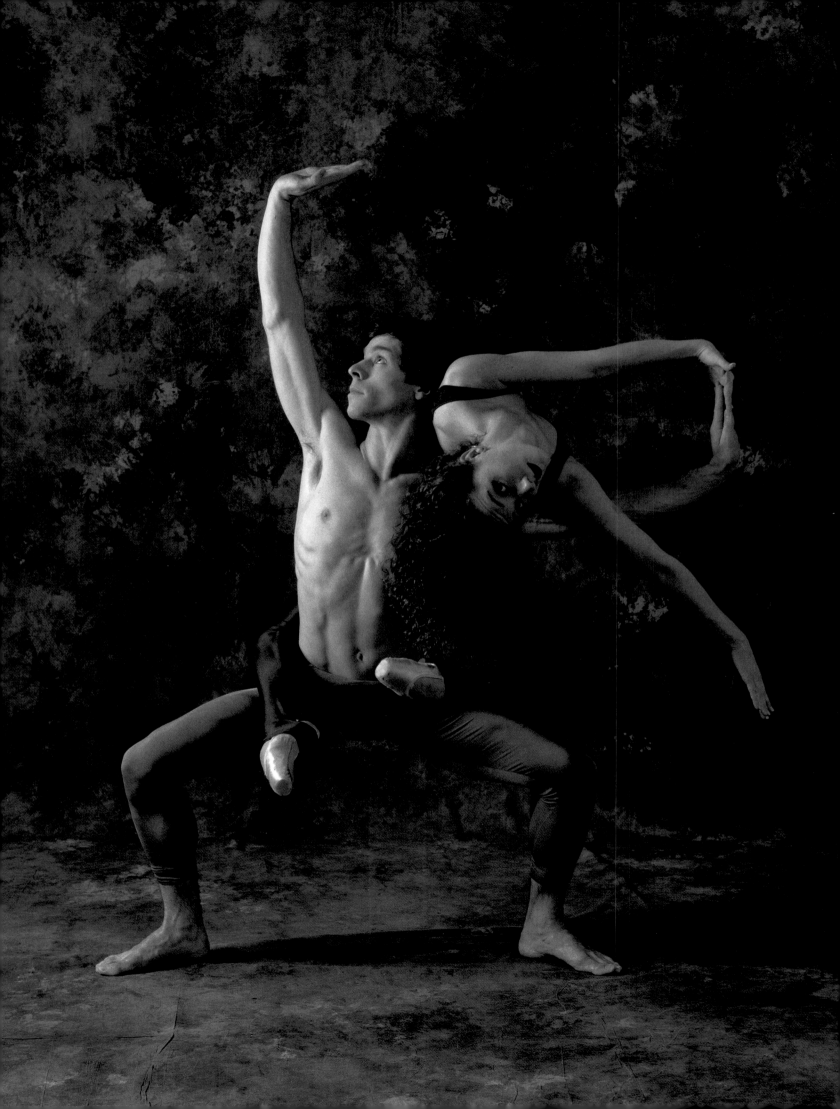

INTERVIEW

RONALD E. COMPTON, ROBERT S. MILLER, NANCY S. COMPTON, PHYLLIS THOMPSON REID

In December, 1998, Robert S. (Steve) Miller came to Hartford, Connecticut, for a conversation with Ronald E. Compton about photography, dance, and the business of running a company. Ron's wife, Nancy S. Compton, and Aperture's Phyllis Thompson Reid joined them for the morning.

• • •

ROBERT S. MILLER: When I first looked at your photographs, I immediately thought, well this is wonderful. He got some ballerina to pose, maybe asked her to move her hand a little, and made a beautiful picture. But of course you actually make the photographs while the dancers are in motion—what you do is more analogous to news photography because even though [the photographs are] made in your studio, there is an element of luck in capturing something that is not going to be re-run; it's not staged. While the moment is being played out, you have to make quick decisions and your mind, good as it is, cannot process everything. The moment happens and either you captured it or you didn't.

RONALD E. COMPTON: There is a great serendipitous element that I love. No matter how much you try to structure a photograph in advance, it never comes out that way. And the fact that it doesn't, and that there is a surprise at the end, is very much like human performance, where you really never know whether you are going to fall on your face or land on your feet. You may have landed on your feet nine times out of ten, but this could be the time when you don't.

RSM: How much do you try to control the details during the shoot? I asked you last night how much after-the-fact doctoring of the photograph you do. And the answer was close to none; that a part of the art of the photograph is that it has some accidents of history. But take the photograph with the red fabric [*see page 75*], where there are loose threads on the fabric: If Nancy noticed right before you were going to snap [the shutter] and she said, "Hey, there's some loose threads," would you cut them?

REC: Well, probably, yes, in that case.

RSM: I look at the photograph and I think that the threads are part of it.

REC: Here's an example: I noticed early on that my strobe lights don't fire quite fast enough. So there is almost always some small movement—a foot, a hand that is blurred. And so the first thing I thought was, give me a strobe catalog and I am going to pick out the one that fires well—

RSM: The one that stopped the bullet.

REC: And then I realized that I like the idea that I am never sure when I'm in a shoot of what is going to be wiggling in the print. To literally freeze it, in my mind, takes away some of the spontaneity.

PHYLLIS THOMPSON REID: A frozen image, like in sports or scientific photography, is removed from the process of time. Dance exists in time and just that small piece of fluttering fabric can remind you that this photograph is one moment which was part of a continuum.

REC: During the first show I did, people kept asking, "Why photograph dance?" because dance is actually a motion picture, a fluid sport. And I came to realize that I am taking a slice out of this thing that nobody will ever

see otherwise. What is the point of having still photography of a moving thing? The point is that there is so much going on in there that is beautiful that some of it is worth study and appreciation completely on its own terms. Quite apart from the beauty of the motion itself.

This is a mental game much more than it is a technical game. Once you get the lighting down and have made those first choices and you figure it out, all the technical aspect is done. And from then on the camera doesn't matter anymore. What matters is what's going on out there and how your mind and your trigger finger relate.

I have actually found that looking through the camera lens impairs my ability to do good work. But particularly when Nancy is in one of her frantic, Hasselblad-back-loading moods, I can set it up and look over the camera and see the dancer in three dimensions instead of two. I am watching and I am seeing.

RSM: How many exposures might you make in a particular shoot, and how do you go about deciding which are ones you want to throw out or keep?

REC: I hate to admit this, but I actually once had a photo shoot that was four-and-a-half hours long where I shot over nine hundred frames. But there were five or six dancers.

NANCY S. COMPTON: And that was modern dance, which requires many more photographs than classical—because with classical you will get to a pose, [*RSM strikes an arabesque*] as Steve is so nicely doing. Whereas modern dance has constant movement.

REC: In modern dance there is no one there to help you. You are on your own to try and figure out where in that movement is the thing you want. Anyway, I usually shoot between two hundred fifty and three hundred or maybe five hundred frames. The nine hundred was really over the top. And we were all exhausted. Even the dancers were lying on the floor by the time we finished with the shoot.

When I get contact sheets I go over every frame and then I turn them over to Nancy and she goes over them. She sees things that I didn't and often will not like a few that I did. If I go back a year later, I pick out 80 percent of the same ones, but only 80 percent, and I usually see new ones that I like.

PTR: So there is no such thing as the final cut.

REC: I suppose that is a very good term. You know, movie directors must deal with the same thing: If Hitchcock looked at his stuff all these years later, would he have cut *Psycho* differently?

I have been retired only since March [of 1998]. All of this work was shot when I had an eighty-hour-a-week job. I can remember one time where in over two months I never set foot in my studio. So the work, my ability to work both in the studio and in the darkroom, was very episodic. It could be a while between the shoot and making the final print. I was lucky to get in there four hours a month. So most of this was shot under tremendous time pressure.

RSM: With the hobby that I pursue [model railroading], I look back and am amazed at what I got done in the stolen hours while working my day job.

REC: Do you do what I do and lose track of where you are [in the process]?

RSM: I don't lose track that much. If your hobby is a passion, you think about it. You may be going from one meeting to the next but you probably are thinking about it.

REC: I have found that it helped me in many meetings to think about it. Because they were so unutterably boring that I sat there thinking about the last or the next shoot.

RSM: One question is how can a person be a chief executive or a chairman and at the same time do something so completely different. There are people like Ron who have such a broad range of interests in life that they bring the same intellectual curiosity to a project like photography that they do to their day job.

The business of being a chief executive requires different skills every day: You have people problems, numbers problems, organizational problems, marketing problems. You have to go to Washington and get the government on the right track. You've got to motivate your troops. The business of being a CEO is not one-dimensional. And the fact that Saturday you go down to your studio and shoot something is maybe not that far removed from managing your business as you might think.

REC: I don't know how anyone survives without doing it. I know a whole bunch of—what I would term from Steve's comment—one-dimensional CEOs. I am not sure they will live very long. Being a CEO is not

what you would call a full-time job. It is way over the top of that. There is never a moment in your life when you are not there. You don't *go* to work; you *are* the work in that sense. It is in your head. Occasionally you need a piece of paper to remind you what is going on or what somebody else wants to do. But the fact is that you are never out of touch. People know where you are every minute of your life. You wake up in the middle of the night and the work is your first thought.

It requires tremendous concentration. My business life was run in thirty-minute segments from the time I got up in the morning until I went to bed late at night. Every thirty minutes something changed. Almost every day. An hour is an eternity. Fifteen minutes is a good meeting. You only schedule thirty-minute meetings so you can kick people out and have a few minutes to read the mail.

So it's really back to something Steve said a little earlier in the conversation. You do carry that focus into your avocation. You take that into a photo studio with you, or like Steve does, into his railroad.

There is nothing relaxed about [the studio sessions]. You go in there wound up. Your casual conversation is at a minimum. Most of the conversation is "Stage left please, stage right please. Do that again please, all

right. Again. Again please. Again." If you were to record one of these sessions, that's what you would hear.

The dancers respond better to that kind of high-pressure conversation than business executives, who have bigger egos. These are people who spend most of their waking hours looking at themselves dancing in a mirror to find imperfections so they can erase them. They are a lot of fun to work with because they will do anything to get better. Maybe we ought to have big mirrors in all the executive— No, that would just pump up their egos. [*RSM shakes his head, laughs.*] Well, Steve is right. That would just exacerbate the entire problem. I would rather deal with most of the dancers I have met in my life than most of the executives.

RSM: We were talking about the philosophy of Ron's work—computer alteration is so different than the art of Ron's photography, where what he captures at the moment of the photograph is it. And both expertise and human frailties result in that print. And that's it.

Although, here you have a shot that is pure black and white and you have printed it on this lovely [warm-toned] paper.

REC: I don't know who said this first, but photography is not the representation of reality. It should be the illusion of reality. To cast it into another discipline, the paintings by the impressionists look to me far more real than the works of some of the postmodern ultra-realists.

The question of what paper surface you use is part of the decision-making process of what "real" means for this picture. Should it be in color or black and white? That is a decision. Or, "Are we going to shoot this in 35 mm so it's going to be a little bit grainy?" You don't necessarily try to get grain-less stuff, you utilize these formats to create a mood.

RSM: In the same way that you leave a little motion within the shot, which is otherwise still.

REC: I am an unrepentant impressionist. I realize that in this day and age that is not nice, but I am.

RSM: You have been critical of the use of trampolines in dance photography because it is not the way that the dancers actually do their craft. At the same time, you shoot a lot of nude dancers, which is also not the way they do their craft. How do you sort that out?

REC: Well, first I would argue that no one has ever accused me of being truly consistent. I think consistency is not necessarily a great virtue. But I want to know that the dancer really got up there on his or her own. And that is real to me. But so is the nude. Now there is dance performed nude. Almost all Butoh is performed nude and probably more dance should be. We're not talking sleazy strip-joints here.

If you don't like it, don't take the picture to begin with. I am not going to take a picture of somebody in a leotard and then build a costume with a computer program. Because that wouldn't be what really happened out there. But I don't see an inconsistency [in the nude work] because these are studio portraits; I am not trying to represent what occurred on a stage.

Snowden just did a retrospective of his theatre work. And I can't remember a single photograph in the book taken during an actual theatre performance. And yet it evokes the theater for me. Nancy has suggested to me that I photograph the preparation for dancing. Watching a ballerina putting on shoes is a real event.

PTR: While the work here is about the apotheosis of that preparation, that effort, about the moment that reaches "grace."

REC: Meanwhile, we all know they are breathing heavily, their foot hurts, their arm got injured yesterday. . . .

When I was in the early stages of this work, Melissa Harris [a senior editor at Aperture] made this statement. "In the greatest picture you are ever going to see of a basketball player, the ball will not be in the basket." Because even for the greatest player, the whole attitude of his face and body is going to change when he knows for sure that ball is in the net. But there is just that moment before the ball goes in—and one of the things I have tried to do is to shoot at a moment when there is that tension. When that dancer is not at the peak, when the lift is not at its apex. And I even sometimes wait long enough so that the dancer begins to fall out of the pose.

RSM: I am hanging up here, I am hanging up here . . . are you going to take the picture?

REC: The woman on the cover of the book, Nicole Sistare—I have only photographed her, I think three times. [But] for some reason, I caught her

timing. We were whizzing along through a session once and she said, "You're getting it. Your flashes are going off on my timing." Somehow I understood when she was making those decisions and how far she was really going to get into the air.

RSM: Have you had some dancers where you just didn't click with them? Or [who] didn't react well to you?

REC: With some of them, I've taken many frames and never really got to the point where I understood their mind. You just don't do it again. Or if you do, you do it because they need it, they need resumé shots. The pictures are important to them because that's the next job.

It is a very, very tough thing for them. Particularly in a small regional companies like some of the ones I photographed for this book. Or the modern dance companies, like those of Judy Dworin and Laura Glenn, that I photograph. It's a miserable life. It really is. They only do it because they are compelled to do it.

RSM: You have to have the passion to be good at it. It has to be what you want to do.

REC: I think I understand dancers and others more than I would've had I not been a CEO. Because I know what

it means to do something you are probably nuts to do but do it because you can't help it. I am really a pathological problem solver. And that is one reason I like this. Because everything you do in dance photography, fundamentally, is a problem. How to get this [effect], how to get that. How to do this.

PTR: And nothing is guaranteed.

REC: Right. But you do get the answers a little quicker than if you are a CEO. By the time you are looking at the print you understand whether you got it or not.

• • •

PTR: When did you start making your studio portraits of dancers?

REC: Ten years ago. We rigged up the basement to [photograph] in and used the basement to shoot the stuff for a long time. Until I got so many ballerina marks on the ceiling, from lifts. . . .

But I have been photographing since the earth cooled. In fact, I was living in Independence, Missouri for a while and I made a darkroom out of a coal bin that still had coal in it. Kind of antithetical to the idea of a dust-free environment. But that is what my grandmother had in her house. I have been photographing things since I was twelve or thirteen years old.

NSC: He made money in college photographing weddings.

REC: I did. I worked my way through most of college at Northwestern— which was a hell of a lot easier to do then than now. I lived at home because I didn't have the money to go away to school. One of my close friends was a divinity student at the theological seminary. So he had an "in" to the weddings. . . . We had a deal, sixty-five 5-by-7s for sixty-five dollars. We shoot your wedding on Saturday, I develop the film on Sunday. Don would come over Tuesday night and we'd print in my bedroom, which we'd black out. We'd do the sixty-five prints, deliver them on Thursday, take our sixty-five bucks and hope we had a job the next weekend.

It was still the early days of strobes. The one I was using had these two bare prongs and you stuck the prongs into receptacles in the front of the camera. So, I am in this wedding and I am really swinging. . . . And just as the bride is putting the piece of cake in the groom's mouth the contact fell out of the front of the camera and I reached down and I discharged it, thousands of volts, right through my hand, and fell flat on the floor. Boom.

• • •

PTR: What music do you play during your shoots?

REC: I almost never do. It's rare.

PTR: Then how do the dancers keep their timing?

REC: Oh, the dancers don't need music. Remember, there was a skater in the Olympics where the music blinked out and he did the entire Olympic performance without any sound at all. Well, dancers can do that—they count their way through it. But occasionally they bring in rock.

PTR: So they listen to one thing and dance to another?

REC: They'll come in and they'll say, "Hey Ron, put this on." You put it on and it's the same stuff my kids listen to. And then they will go out and dance *Swan Lake*. In fact, many smaller regional dance companies can no longer afford live music. The artistic directors will tell you that it is ruining the companies, because there is no spontaneity. People have danced to the same recording so much that they don't need it anymore—they are counting the way through the piece perfectly and they stop listening because they don't need to.

RSM: Without the music, then the sound will be just thuds as the dancers hit the floor. I think it would be disconcerting.

REC: They hear that all the time. If you ever sit up really close to a performance you will hear thumps and bangs and all that. And that is what they hear all the time so it's not disconcerting to them at all. It is a little disappointing when you find out that dancers really are physical things and they hit the ground and they go bang. They aren't floating in air at all.

PTR: Do they improvise when you are working on shoots?

REC: Sometimes I have no idea where they get the stuff.

PTR: So you don't necessarily choose a piece of choreography and photograph from it?

REC: I have done that a little. I have also been asked by artistic directors to photograph specific pieces. More often than not, though, what the dancers are doing is sort of a mystery to me. I don't try to direct them or correct them. I am a voyeur. There are really two kinds of photographers; picture-makers and picture-takers and I am definitely a picture-taker.

I understand about Ansel Adams and the zone system and pre-visualization, but I absolutely cannot do it. I try to imagine in my mind a photograph that I want to take and I can't do it. My

best stuff comes from exploring the subject with the camera. Basically I am a street photographer working inside.

RSM: What do you think of Annie Liebowitz? Is she a picture-maker?

REC: No question that as to technique, she is among the best in the world. But her imagination! The picture of Whoopi Goldberg in the milk? That is a *made* picture. That's not a found object. She just imagines these fabulous scenes.

PTR: What photographers are important to you in terms of your own work?

REC: Max Waldman is important to me. I recently found out that he did his work in a small, confined space. This is a guy who utilized the limitations that were put on him. And I think everybody has to be influenced by Weston. The breadth of his work is stunning. And Ralph Gibson, of course. If you gave me a roll of film or a single holder and said, "go take something" I would not do it. And the reason I wouldn't is that the sense of frustration would be so overwhelming that I would be unhappy. Every picture, every frame I take, gives me at least one more idea. And you can see in the contact sheets that I get an idea and work up to it for three or four

frames until I am happy that somewhere in there I got it.

I was over at the Hartford Art School a while ago and we walked through a life-drawing class. On the way out, I looked at these charcoal drawings that eight or ten of these students had done, and no two were even remotely alike. And I thought, "I could never do that." Because they were taking their subject, this woman, and they were interpreting it in a way that photography doesn't really allow you to interpret. And I envy that too because they are superimposing the imagination.

RSM: But if I went into your studio and shot the same dance sequence you did—

REC: It wouldn't look like that.

RSM: It wouldn't look like yours. It might well be better. . .!

REC: And many days it would be! A lot of days I walk out of there and think I could have done better blindfolded. I am envious, if not jealous, of those great photographers whose imaginations were the picture.

PTR: Well, it sounds like you are process-oriented. That the way you are going to come to that imaginative place is by working with an idea and exploring it. And it will lead you to the next thing and so the more that you do, the more [ideas] come.

REC: I think that way too. I am an iterative thinker.

RSM: Where would you like to go from here? Would you rather focus in and become known as the world's greatest studio dance photographer or would you rather branch outward and take your hobby from the studio to the Cairo street vendor, to the. . .

REC: I guess the answer, as weak as it may seem, is both. I haven't exhausted the exploration of interior space with people in it. On the other hand, I have learned a lot from walking around streets, including in Cairo, and photographing, and have had fun with it.

PTR: So are you going to start playing golf, now that you're retired?

REC: I guess it is considered by a lot of my peers as some sign of weakness that I don't play golf.

PTR: [*To RSM*] Do you play golf?

RSM: Once a year. That gives me enough shots to take a whole year off.

REC: Exactly. Not to demean the sport. Although I think it is among the duller sports in which one could

participate. Also, if you do what I did and what other people like me do, then there is very little time for your family. And that six hours of Saturday or whatever it takes you to go out and play, that's a big piece. Even to this day, I haven't a clue where I would fit in a round of golf.

I know other CEOs do it by working six or seven eighty-hour weeks and then they just get on a plane and they go away. And they're still on the phone and all that, but they get out of town and they do it because they can go play golf that way.

One of my compatriots here in Hartford, who runs one of the largest companies in the world, is a world-class racing sailor. One year he logged six hundred hours in the air—that is ten sixty-hour weeks. Not traveling, but actually in the air. But he arranges his time and he captains that boat. . . .

Back in the days when we were literally broke, I was complaining to somebody that I didn't seem to be able to have anything I wanted and this person said, "No, you can have anything you want. You just can't have everything you want." You really can do anything you want to do. If I wanted to play golf I could do it. Something else would have to go.

RSM: If you want to see what a typical CEO's life is, I keep track of my flights on a computer. [*Shows schedule; RSM has seldom spent more than two days in any one city all year.*]

REC: Well, Steve can't hold down a full-time job. That's one of the things about him. You know he kids about that a lot. [*To RSM*] You must be the most illustrious failure at retirement in the history of American business. How many times have you retired? At least three that I know of. He just can't get the hang of it.

RSM: When asked to write down what my occupation is, I write down *drifter*.

PTR: Well, you keep going back—

RSM: But I won't sign up for anything that is long-term. No five-year commitments. If a company has a real emergency, that's my thing. And in that case, the worse off they are, the better.

My expectation is and my intention is that I am not going to do any more, ever again. The phone has rung a number of times but unless there is something yet more interesting than the things I have already done, I'm not interested. I knew that the first week of retirement would be great. I was a little worried about what the second week would be like. And the answer is, wonderful and busy.

REC: I was very fortunate to meet Steve when I did. Aetna was a really big company, one of the biggest in the world. And Steve was legendary because of the wonderful job that he did at Chrysler.

Now I am fundamentally an underwriter, a marketeer, a drumbeater kind of guy. You don't start to mess with a giant company without a lot of expertise. I wanted to know if it would be possible to talk to Steve about him becoming a consultant. Not to the company, but to me. So Steve came to Hartford and we talked for a couple of hours. And he concluded it by saying, "You know, I came here expecting to find some boring, dull, stuffy guy in a dull and boring environment. But you've got a lot of problems here!" And so he signed on.

We did a lot of very, very tough things. Things that would break your heart. And as I said, there is not much fun in that. But you only get to do what you have to do.

• • •

Retiring has meant a real change in psychological orientation toward the world for Nancy and me.

The first thing we found out was that when we are really responsible for our own schedules, the chances are, we will screw it up. We packed too much into the summer and the fall and didn't leave enough time for some other things. And we are trying to work through that because Nancy says that she is not going to be happy until she's bored.

NSC: No, I said wait until we get absolutely bored and then gradually take back into our lives the things that are really important. It was just too hectic for me when he first retired.

REC: Can you imagine reading a book during the day? That is the next thing to a cardinal sin.

PTR: Never so much as a novel?

NSC: We haven't gotten there yet. He scheduled two darkroom days this week but didn't manage to keep those days free.

RSM: So much for your unscheduled retired life.

REC: Not only that, but I have to cut this short because I have to meet some people from my art gallery to look over some photographs.

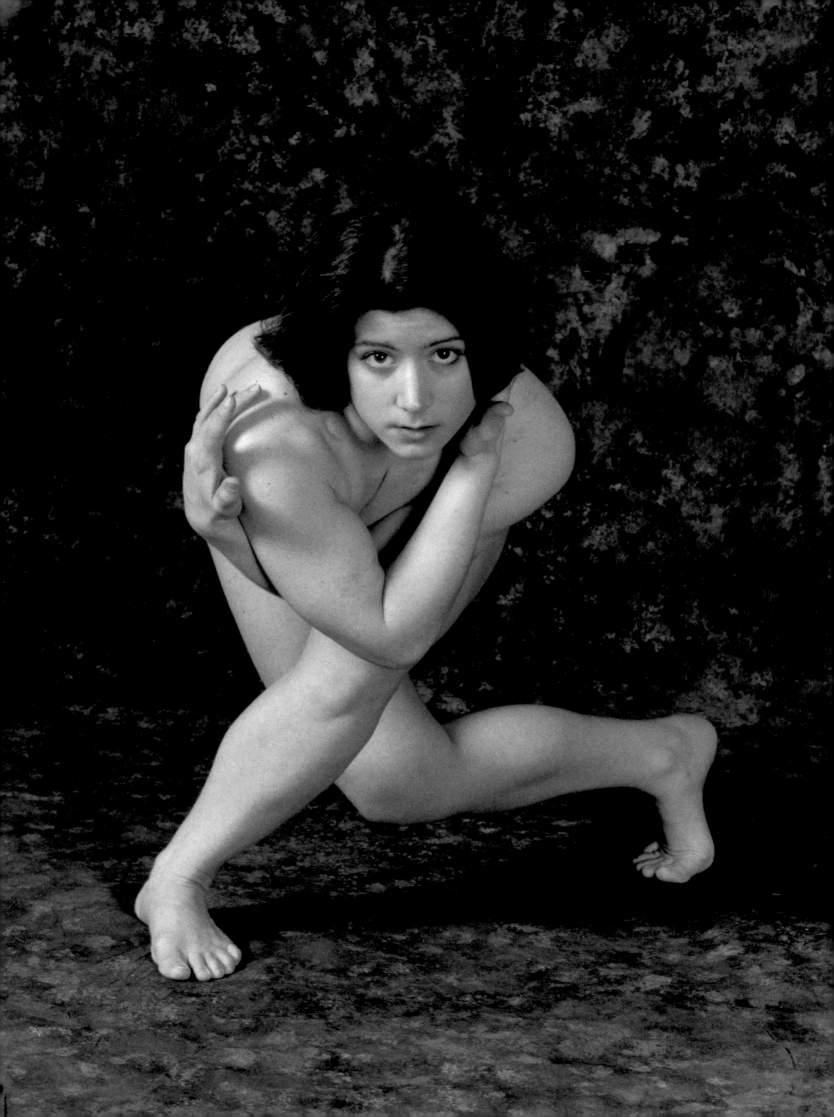

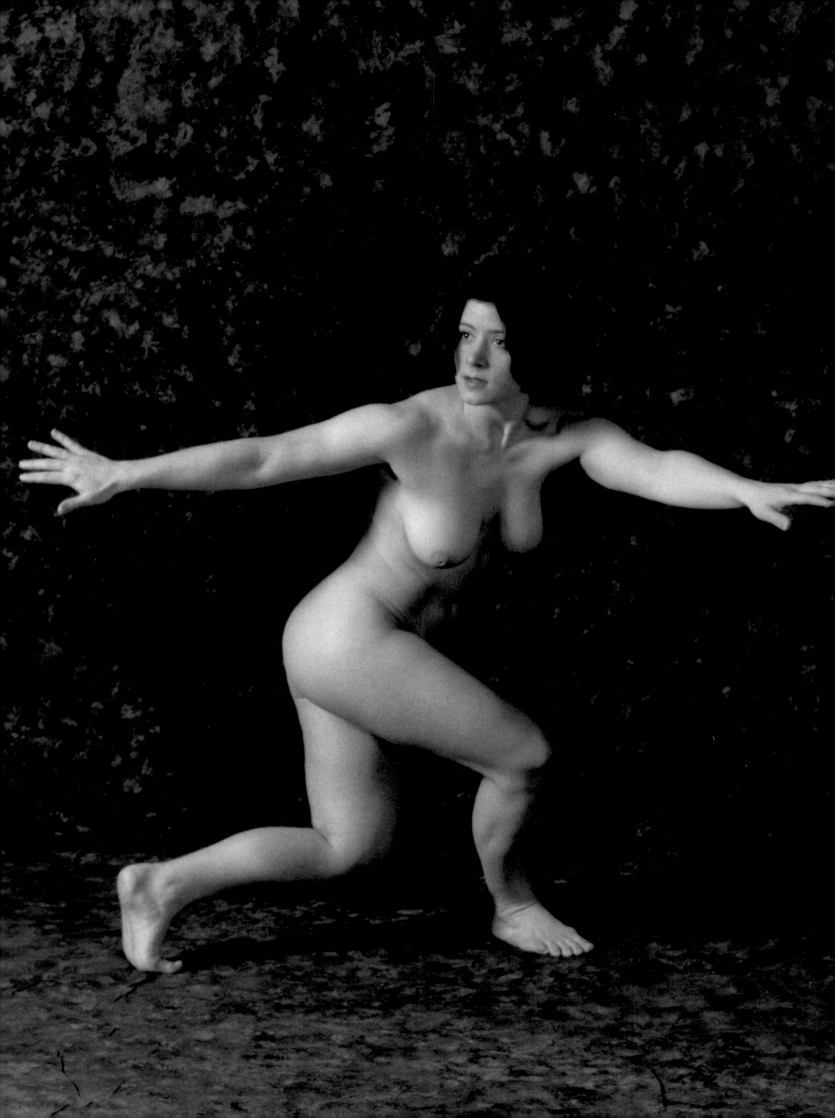

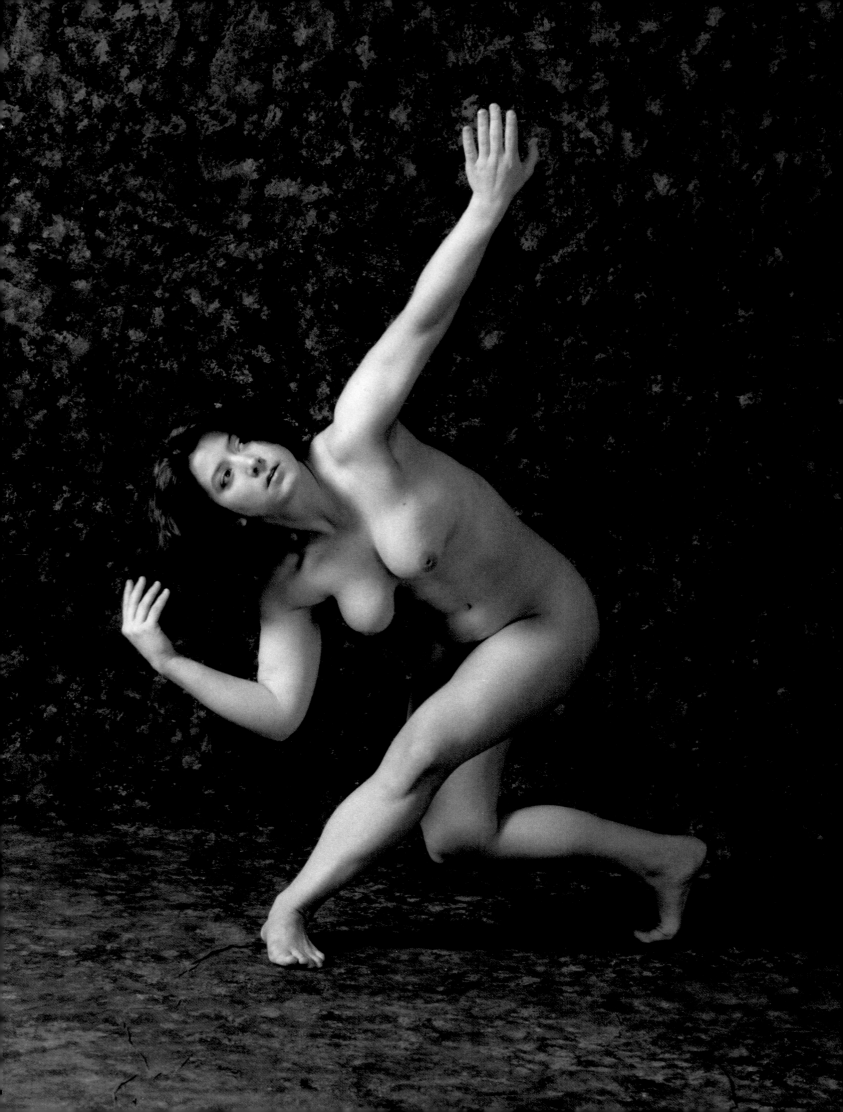

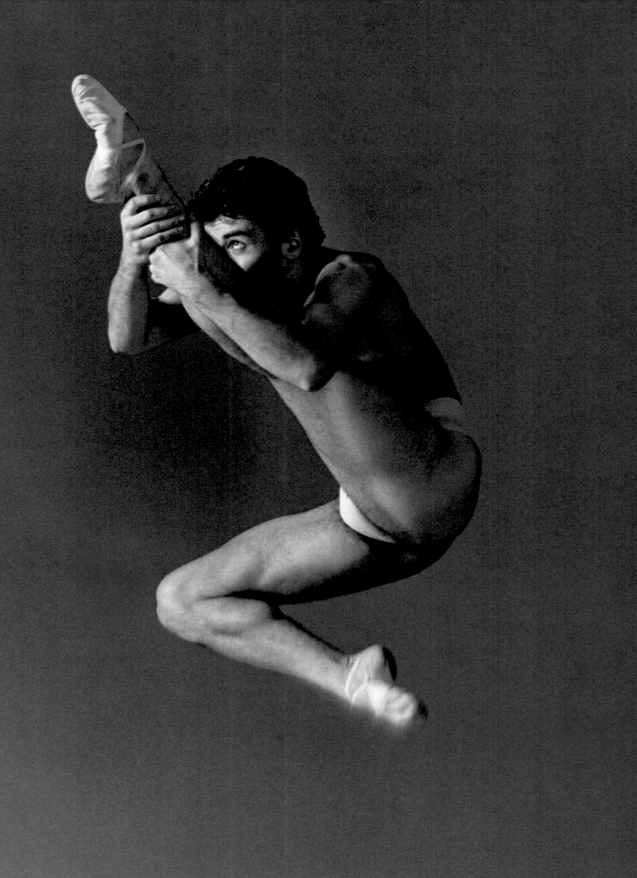

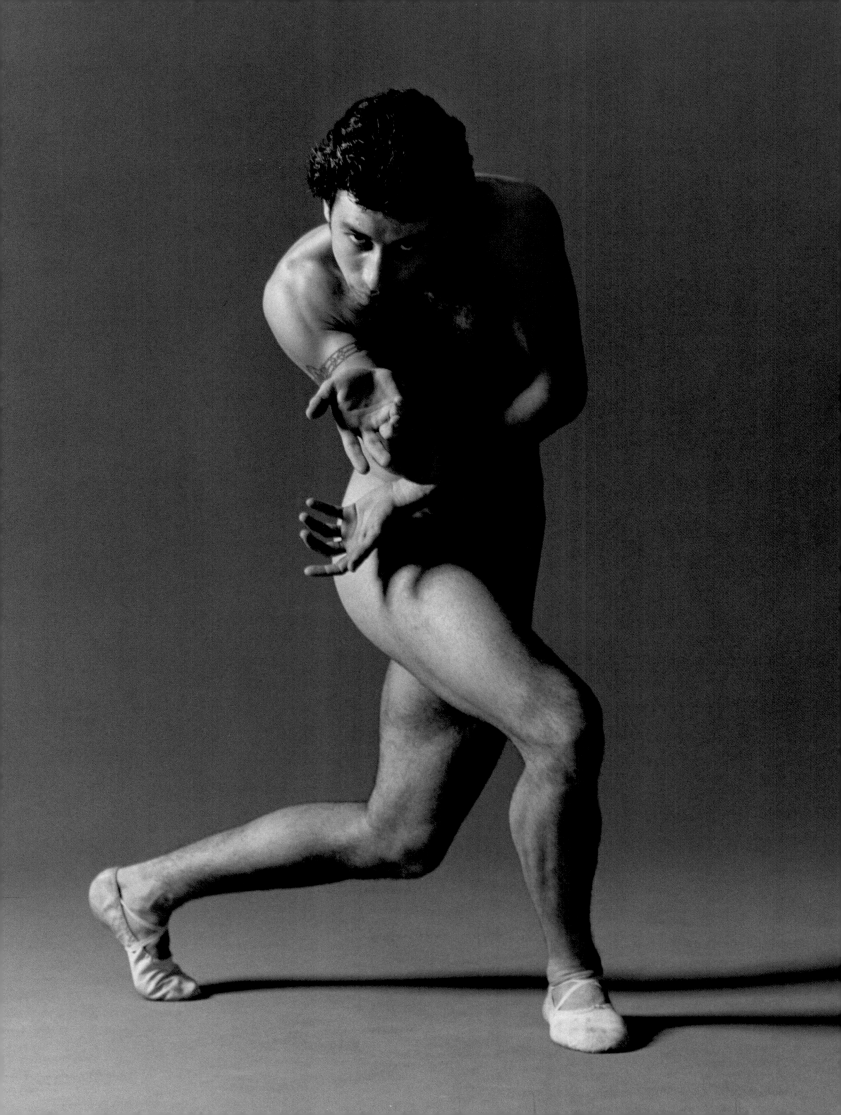

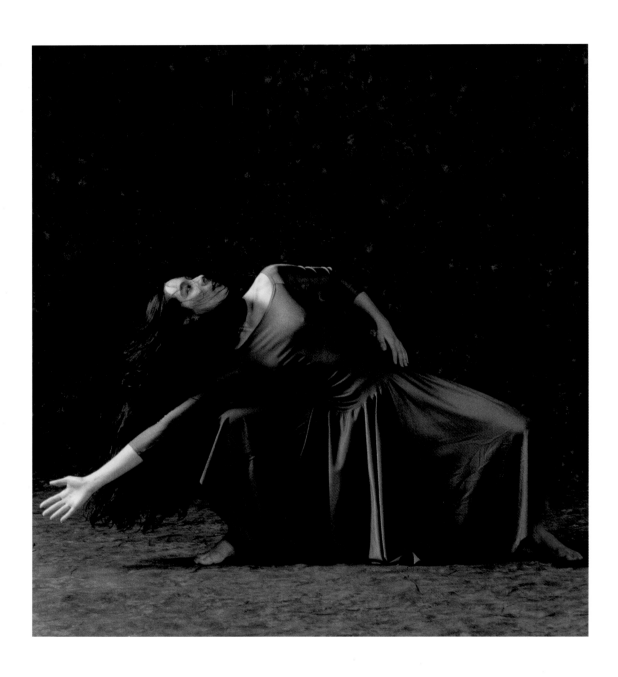

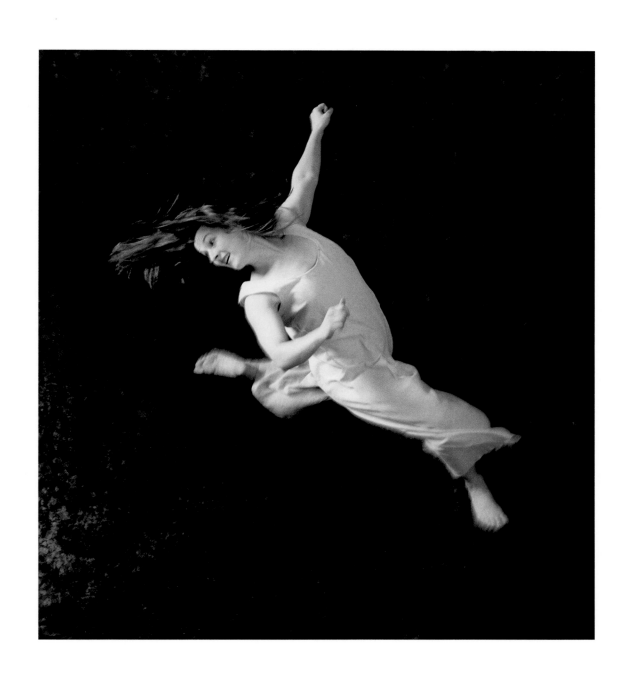

Dancing is the loftiest,
the most moving,
the most beautiful
of the arts, because it is
no mere translation
or abstraction from life;
it is life itself.

—Havelock Ellis

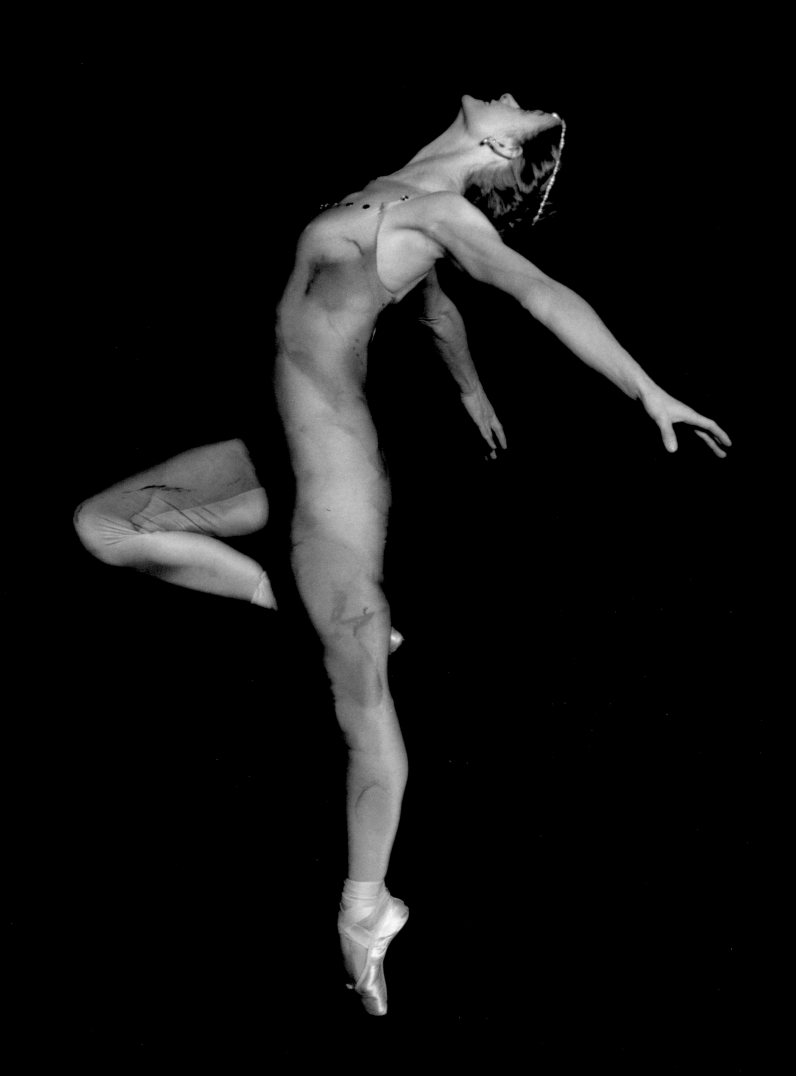

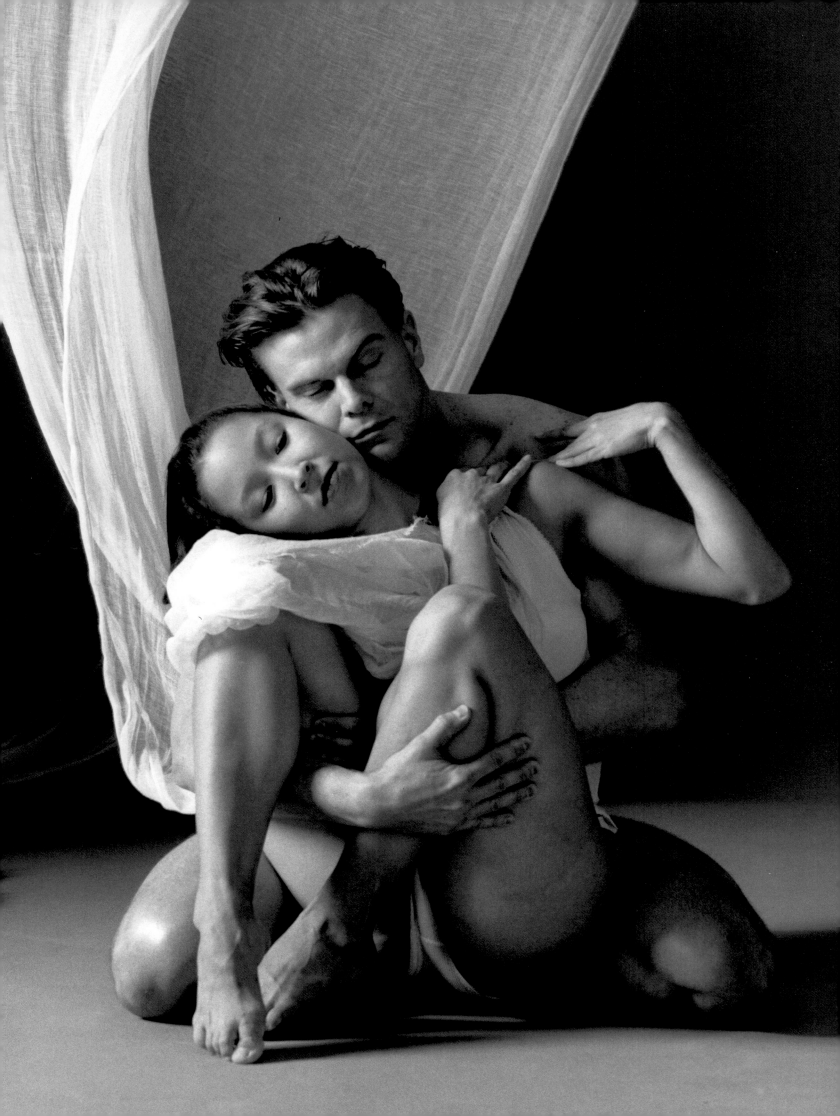

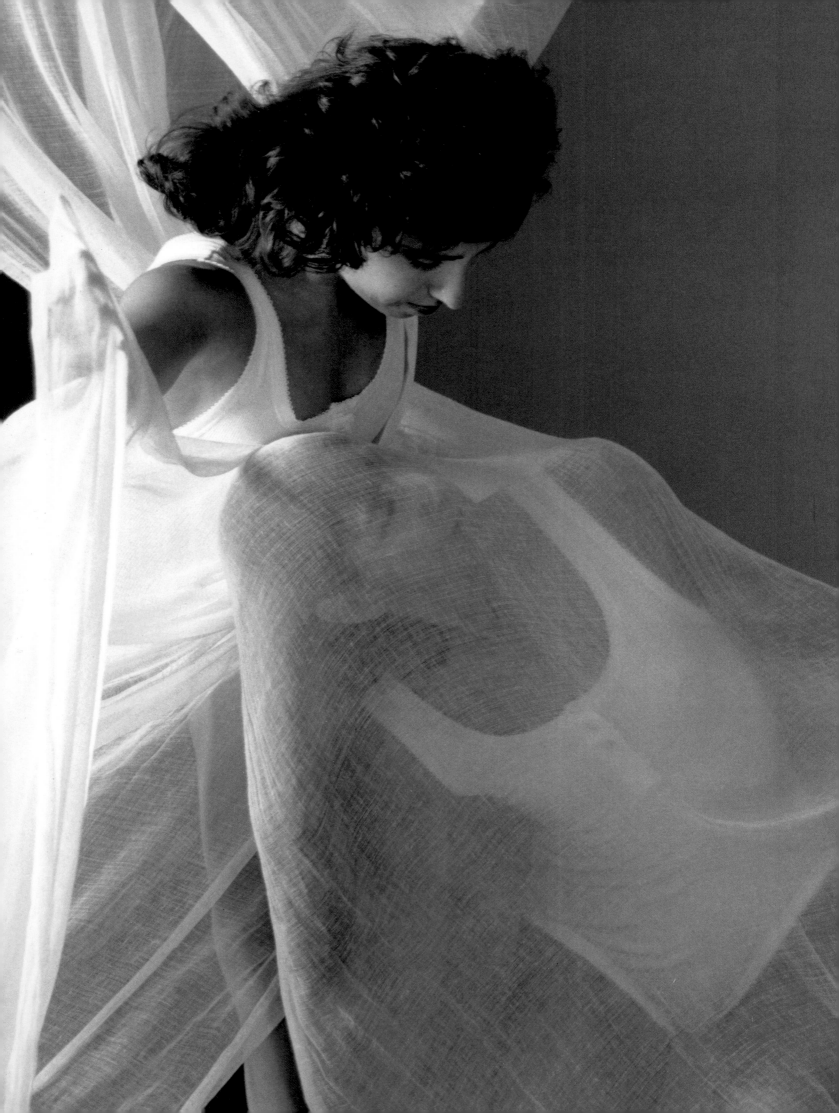

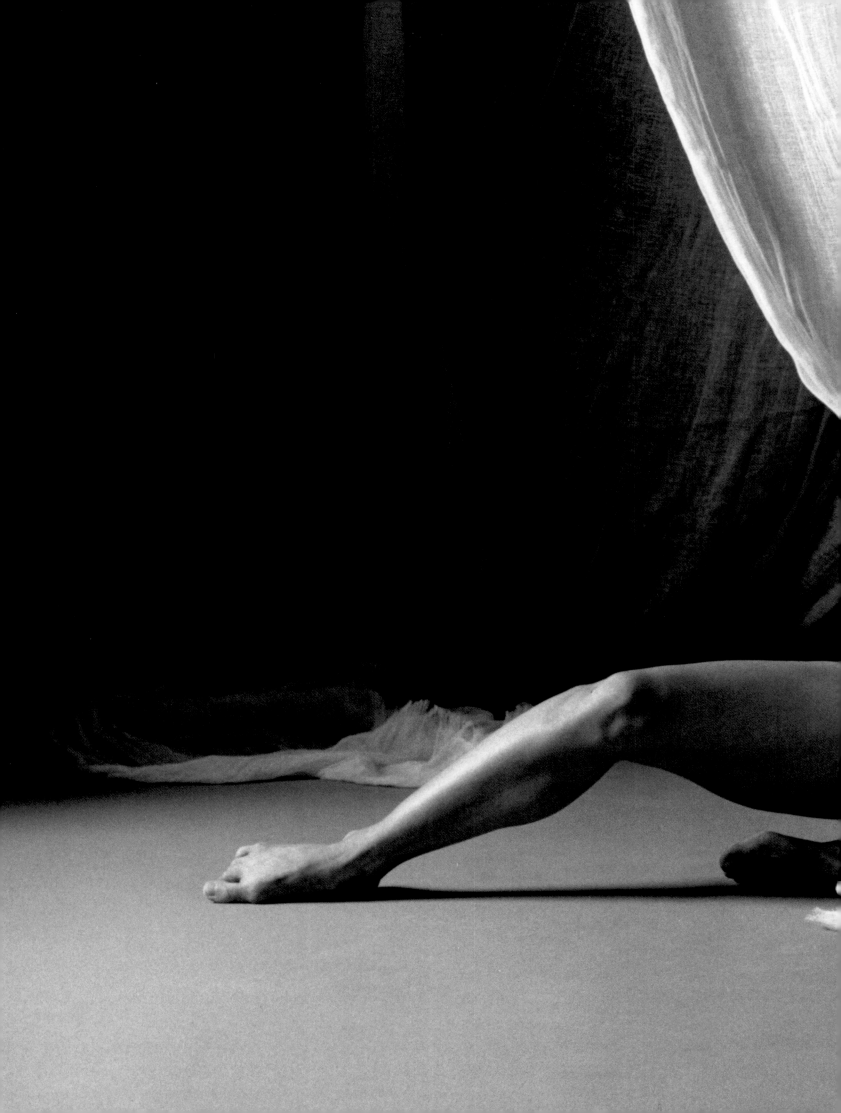

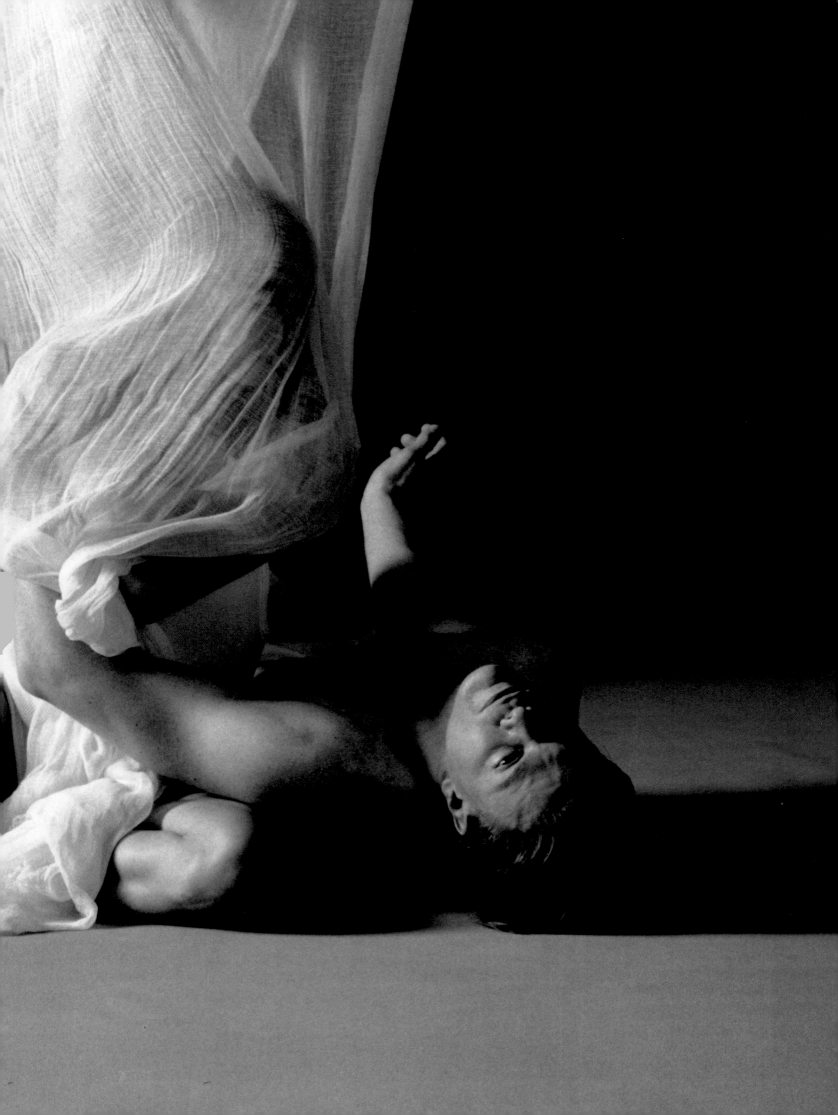

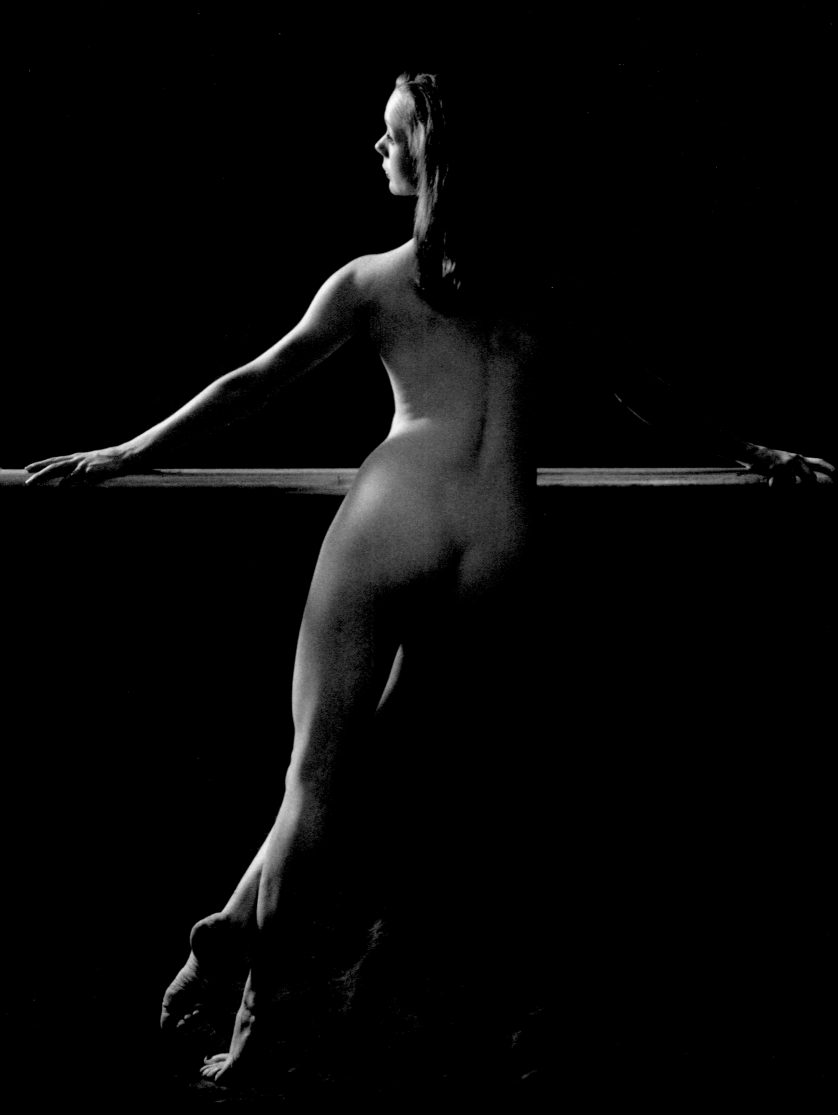

O body swayed
to music,
O brightening glance,
How can we know
the dancer
from the dance?

—W. B. YEATS

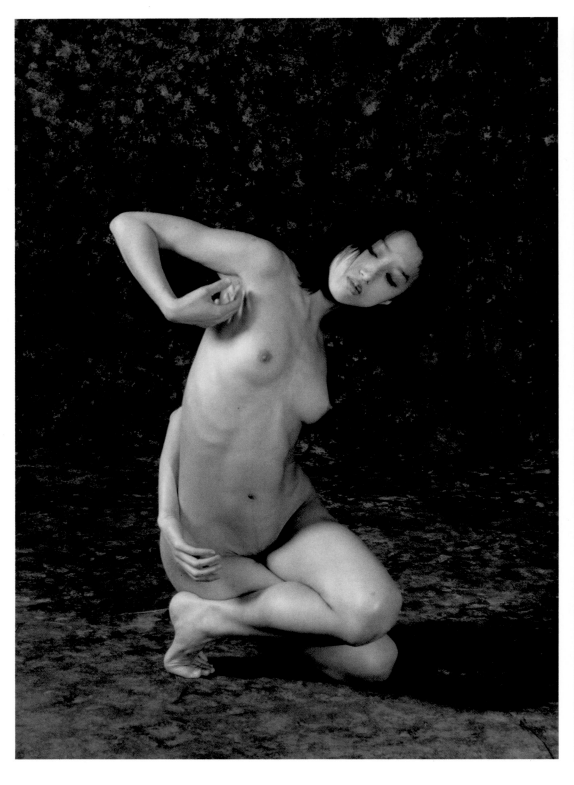

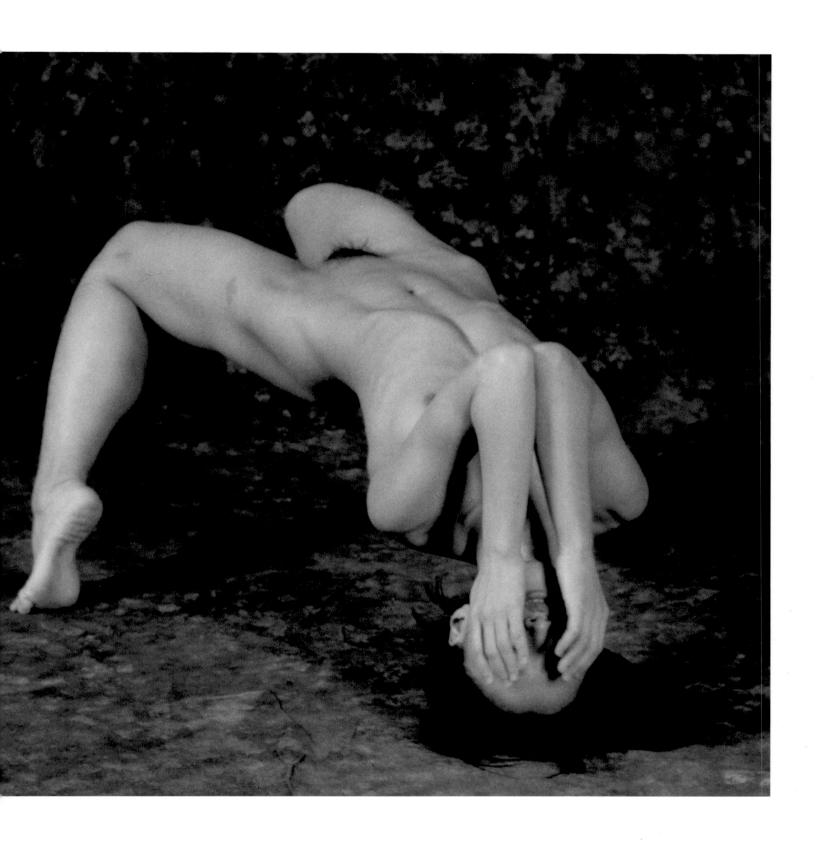

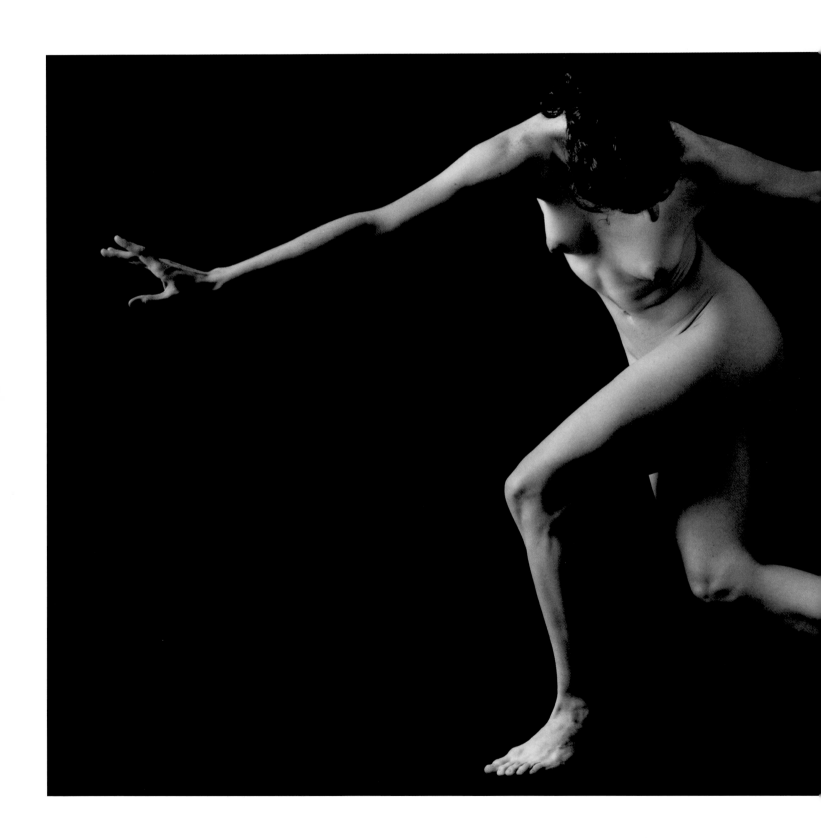

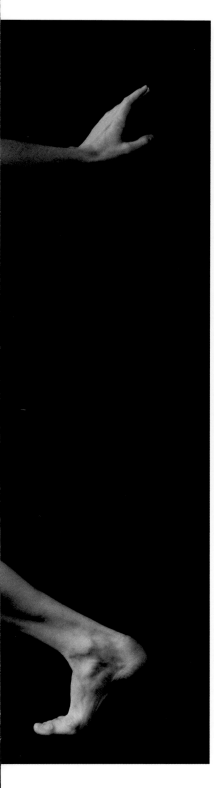
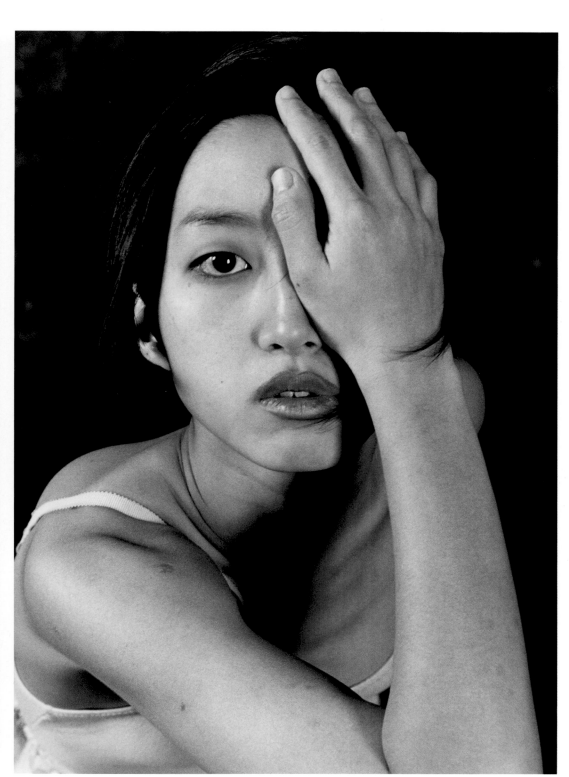

Will you
 won't you
Will you
 won't you
Will you join
the dance?

—Lewis Carroll

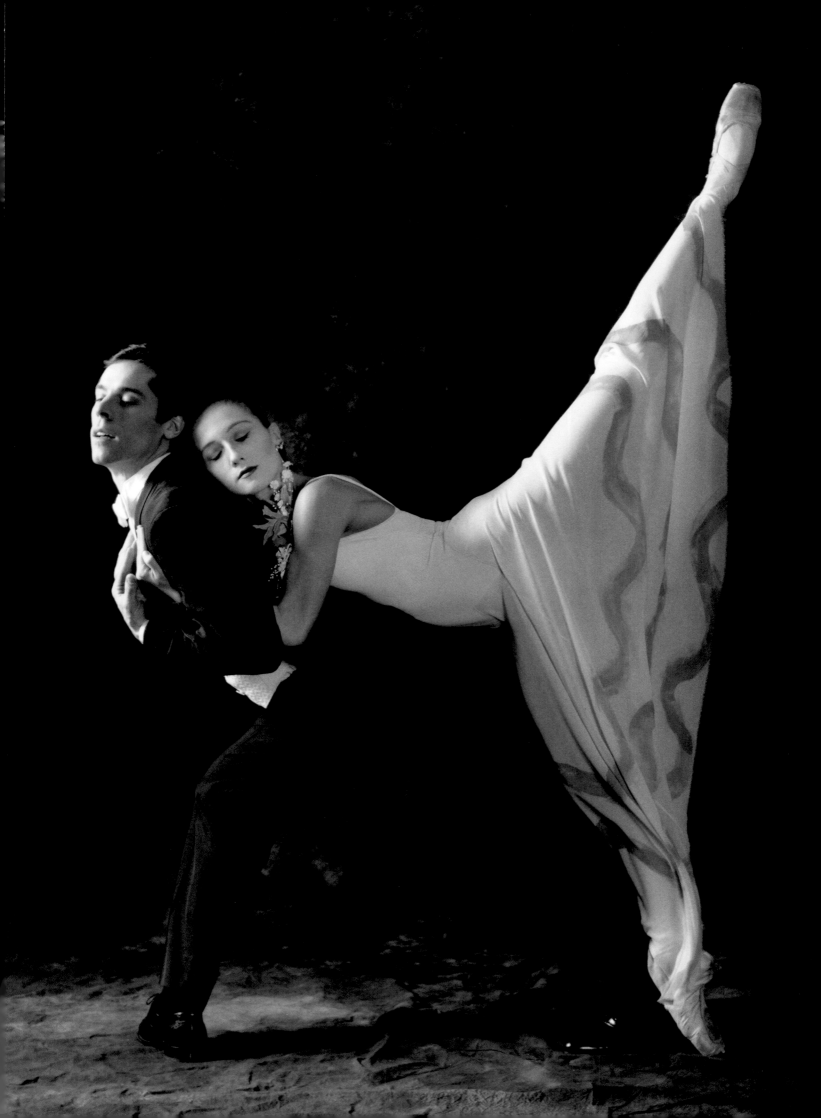

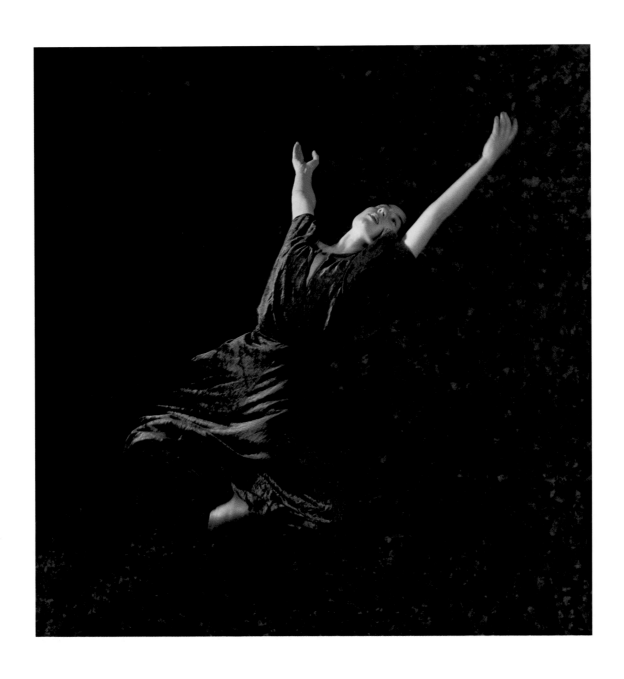

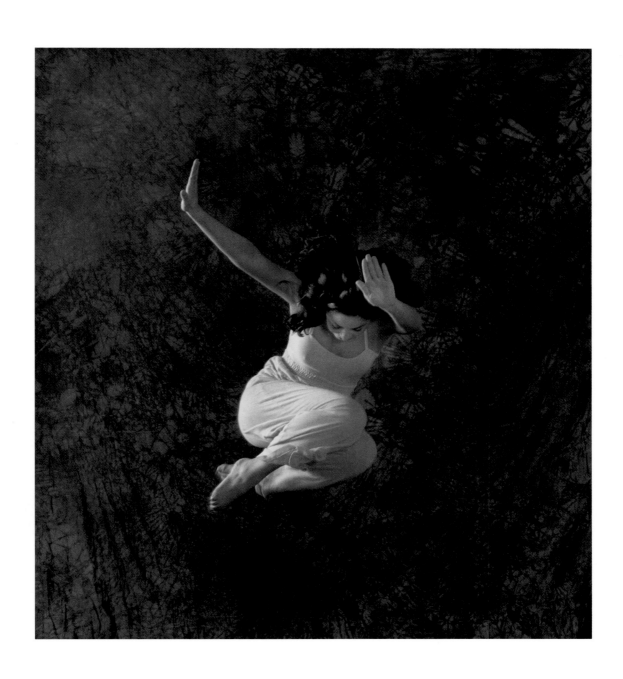

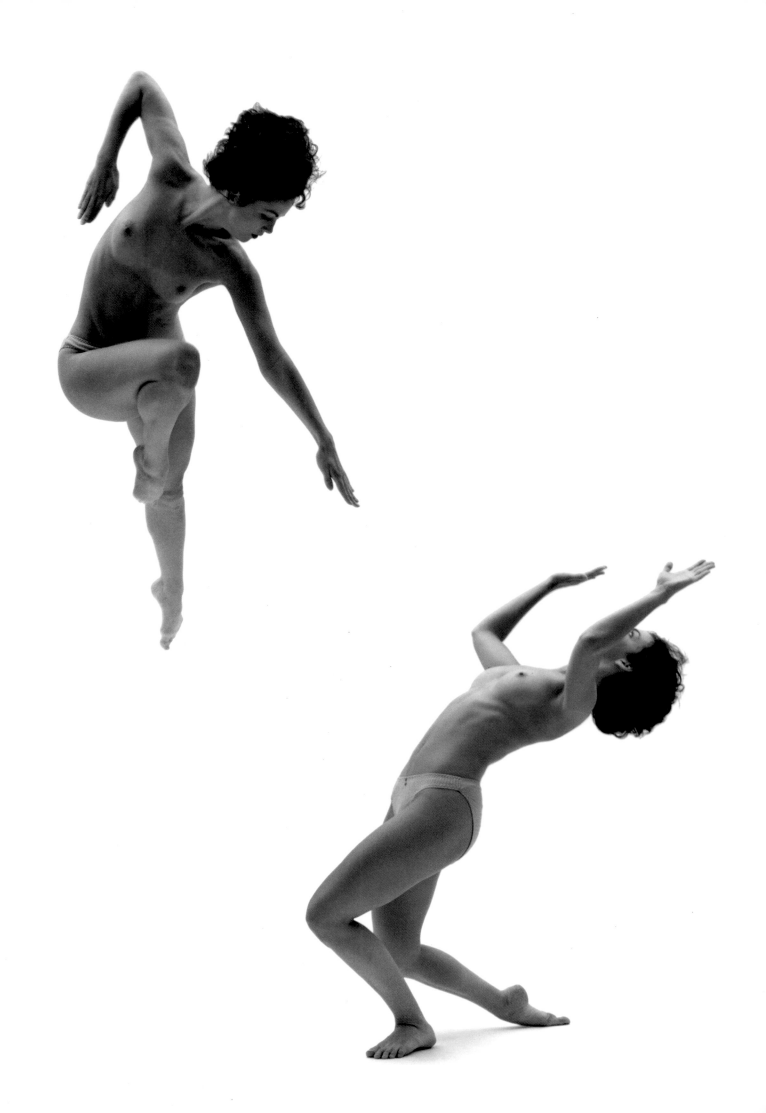

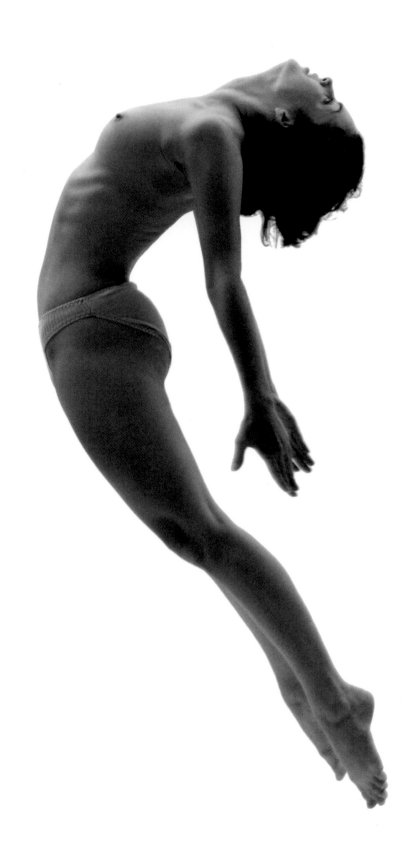

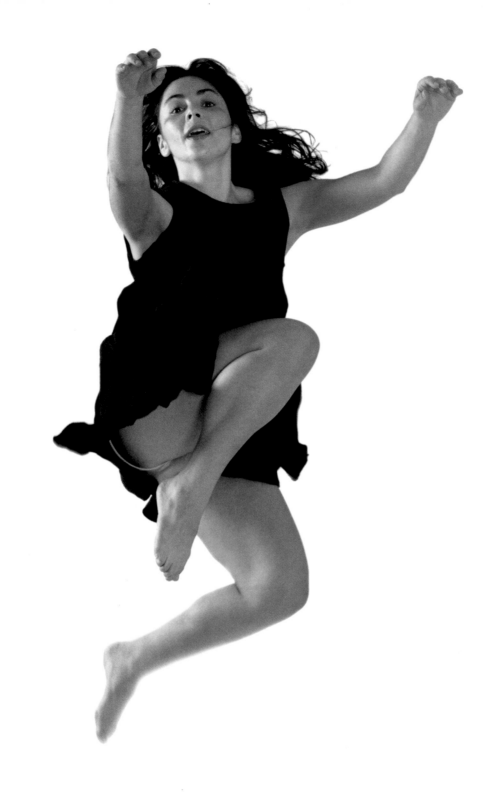

It is sweet to dance
to violins
When Love and Life
are fair:
To dance to flutes,
to dance to lutes
Is delicate and rare:
But is it not sweet with
nimble feet
To dance upon the air!

—OSCAR WILDE

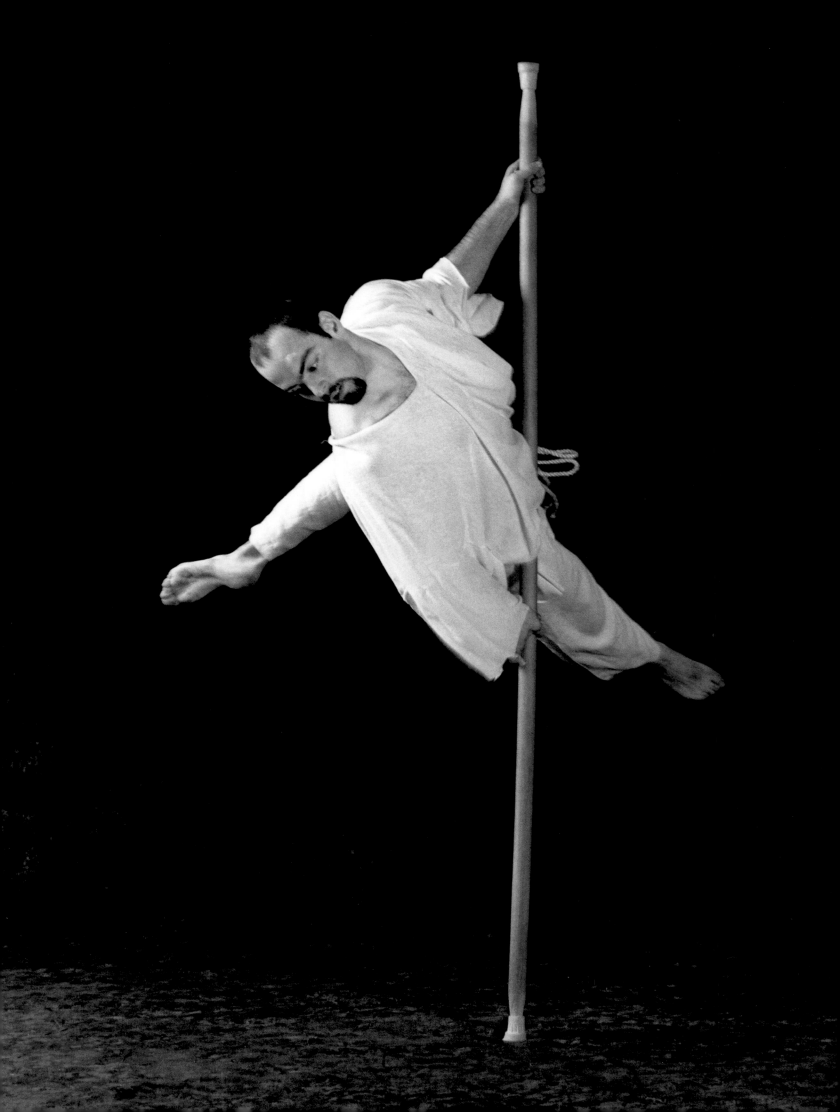

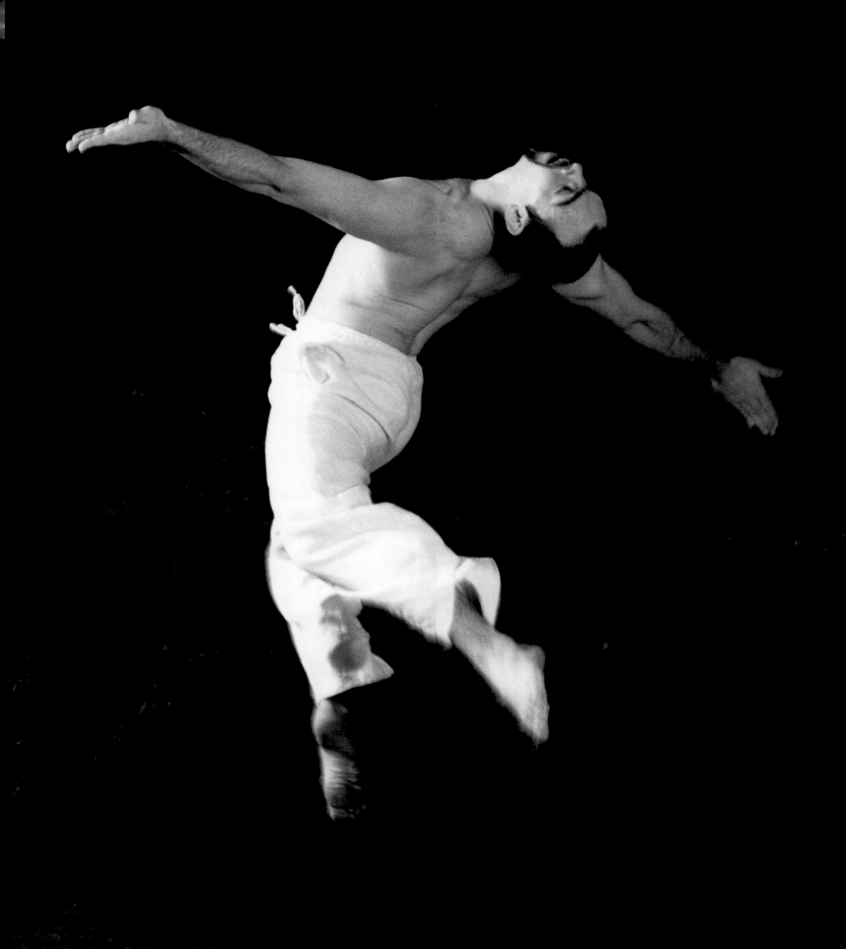

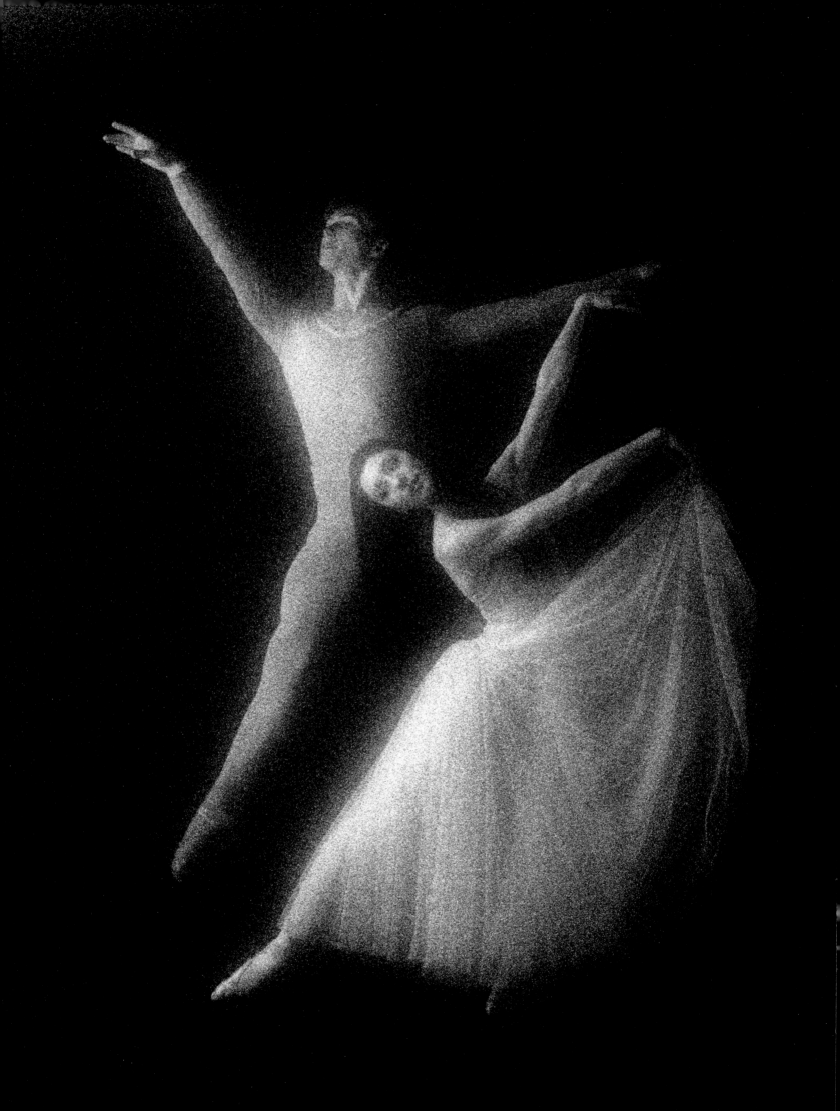

The fairies
break their dances
And leave
the printed lawn.

—A. E. HOUSMAN

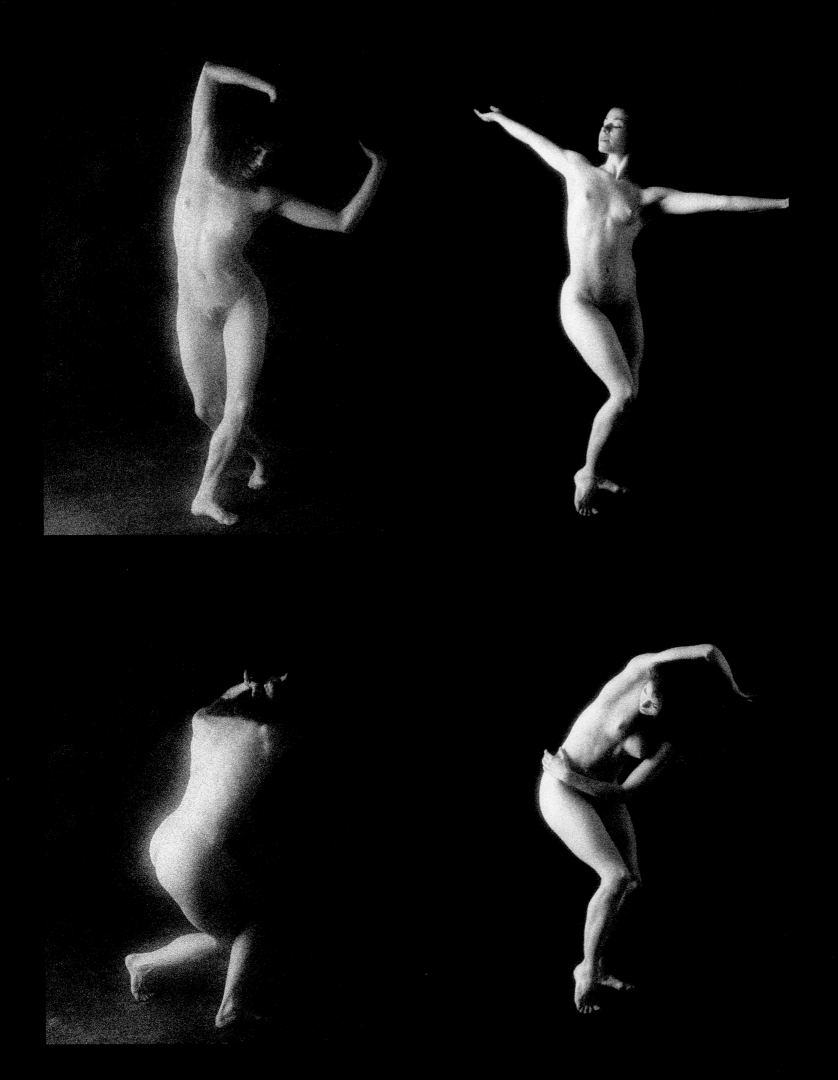

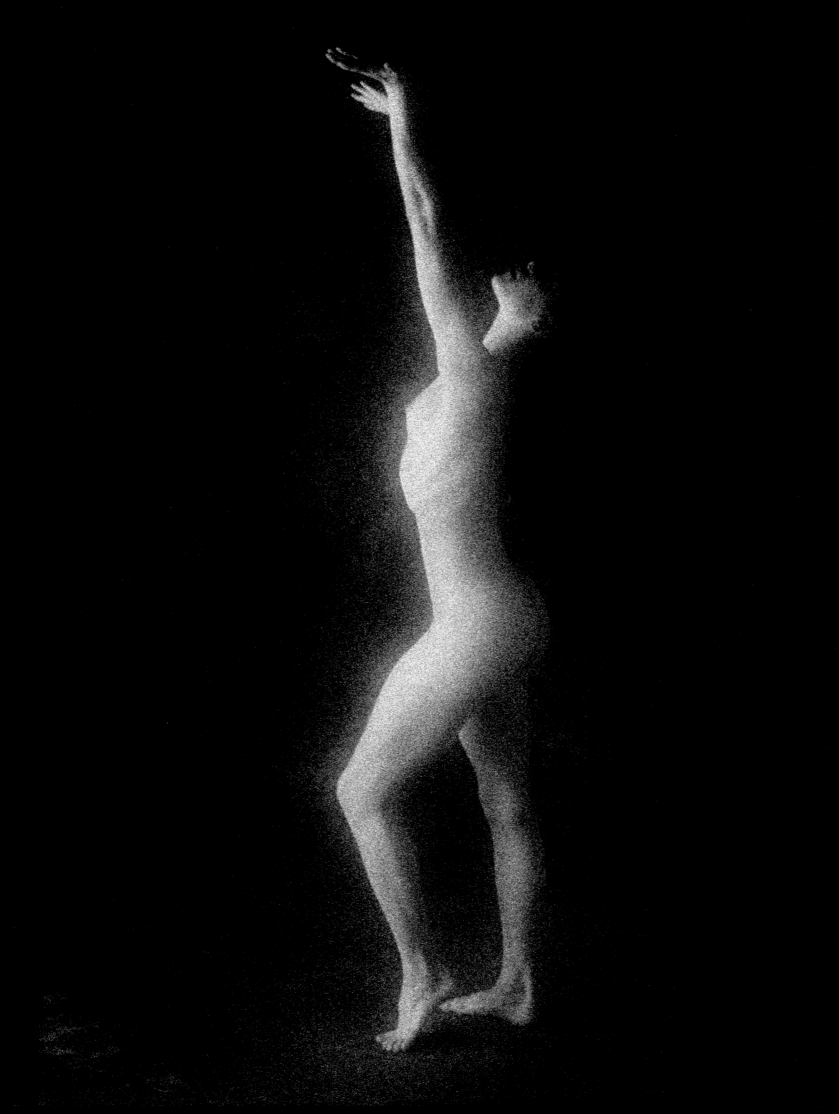

His body is simply
the luminous manifestation
of his soul. . . .
This is the truly creative dancer,
natural but not imitative,
speaking in movement
out of himself and out of
something greater than all selves.

—Isadora Duncan

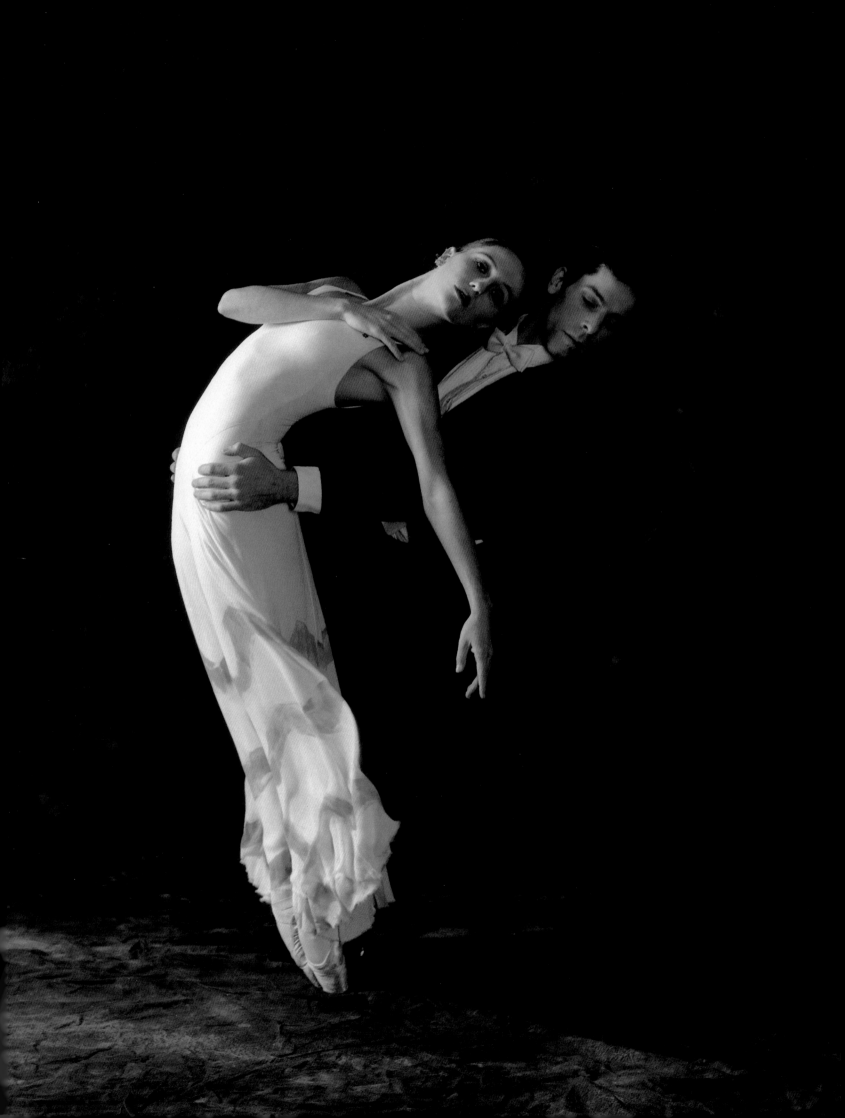

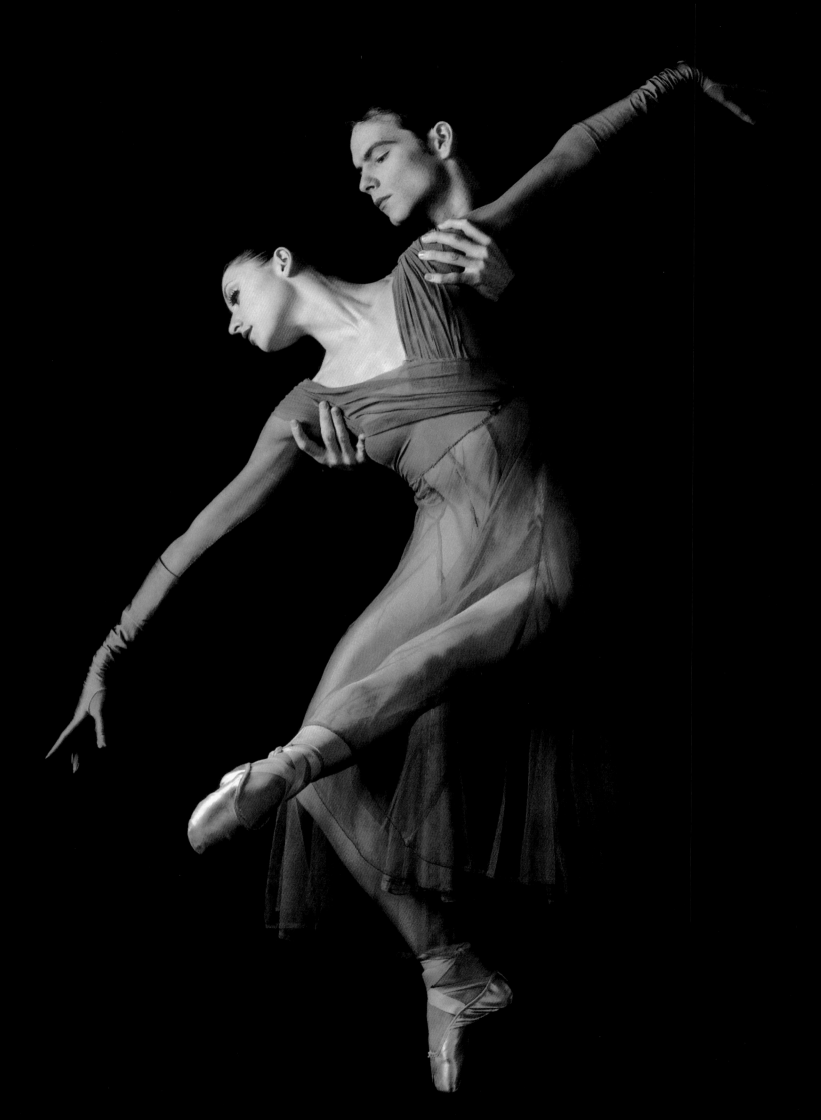

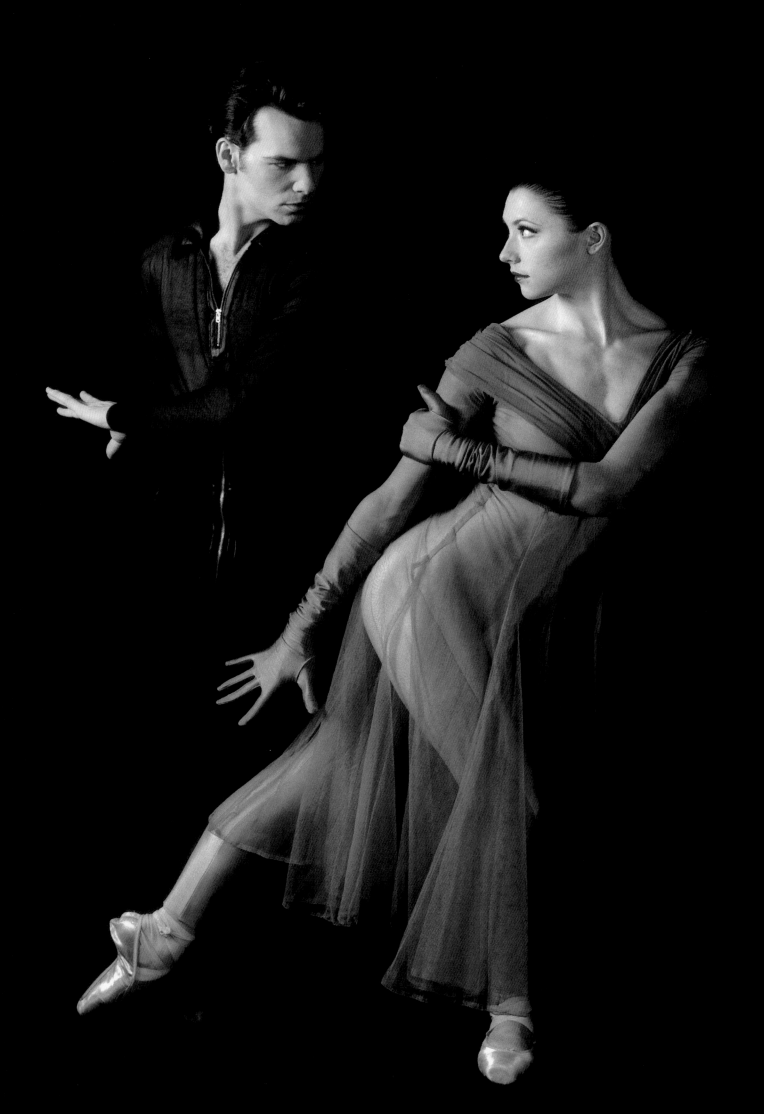

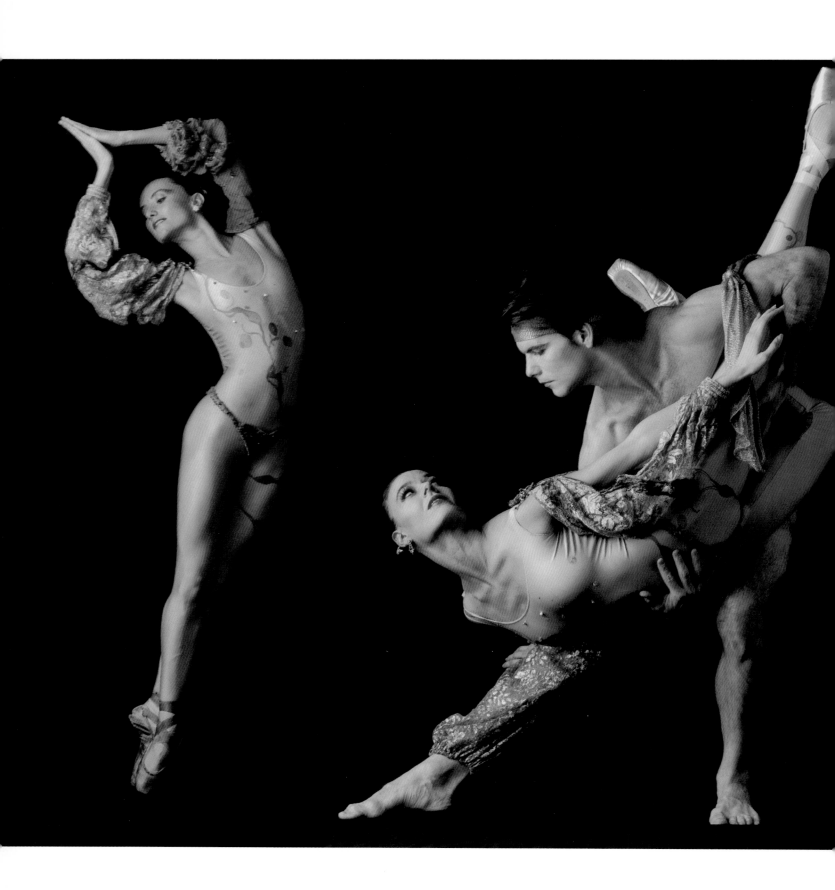

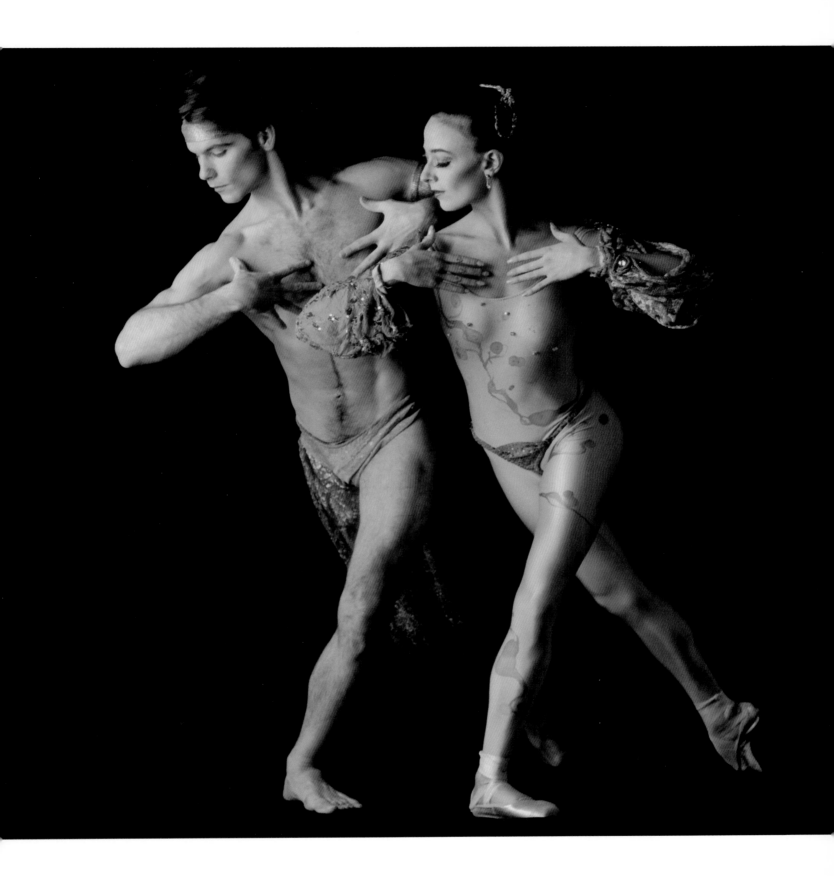

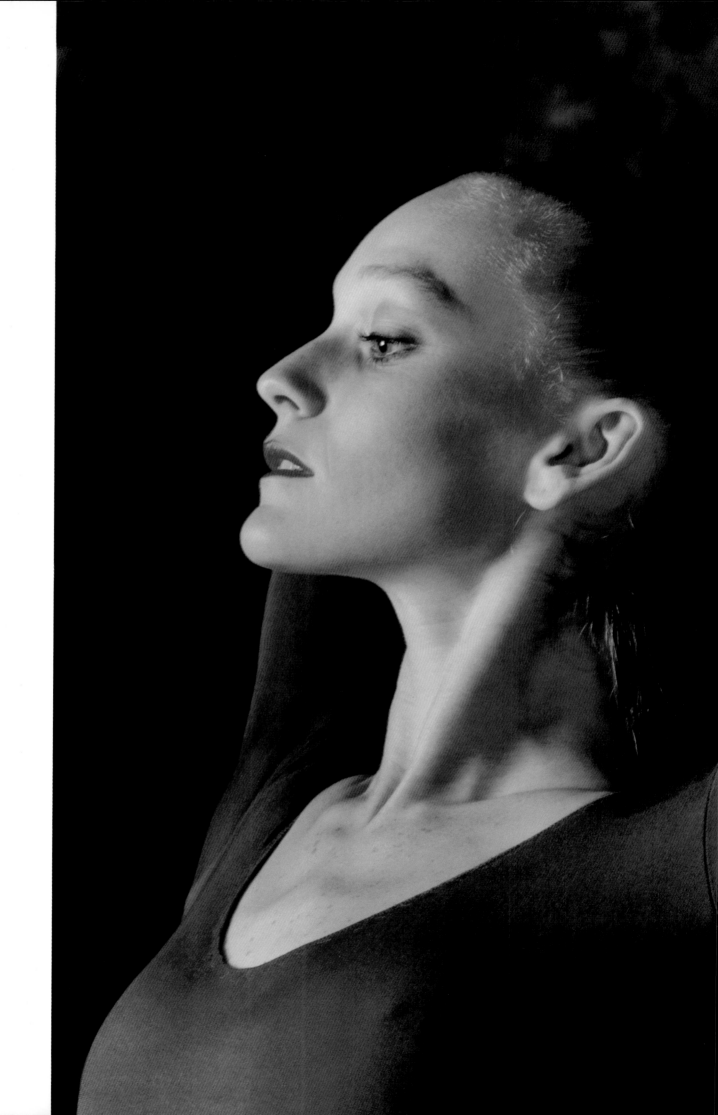

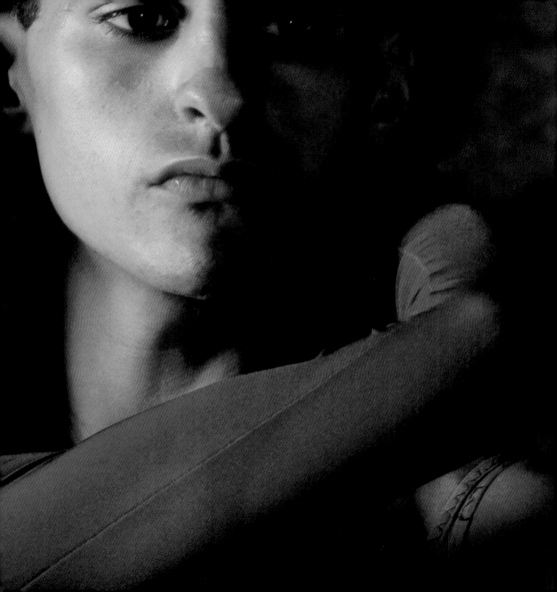

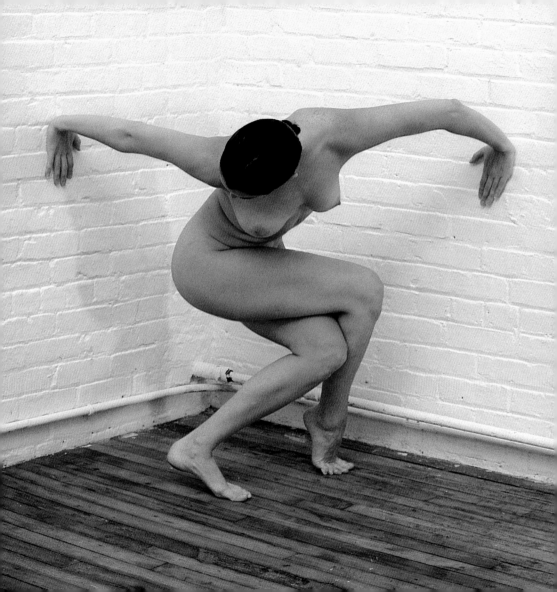

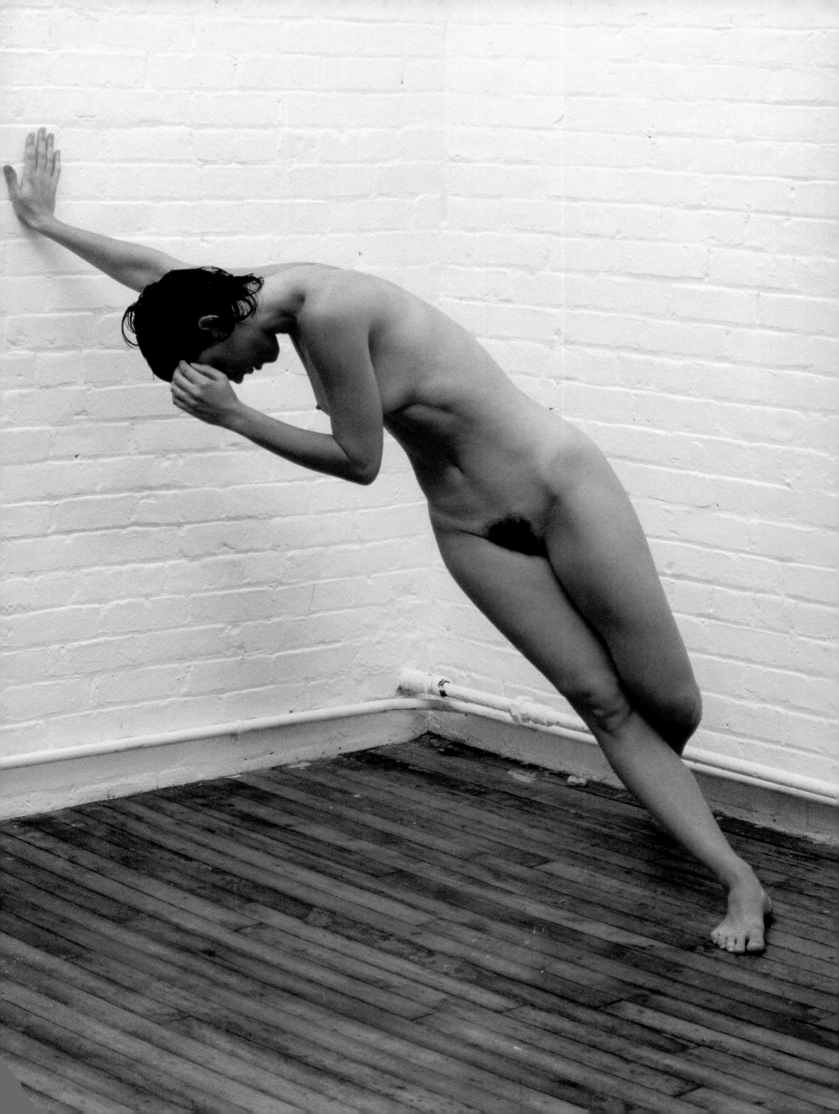

Except for the point,
the still point,
There would be
no dance, and there is
only the dance.

—T. S. ELIOT

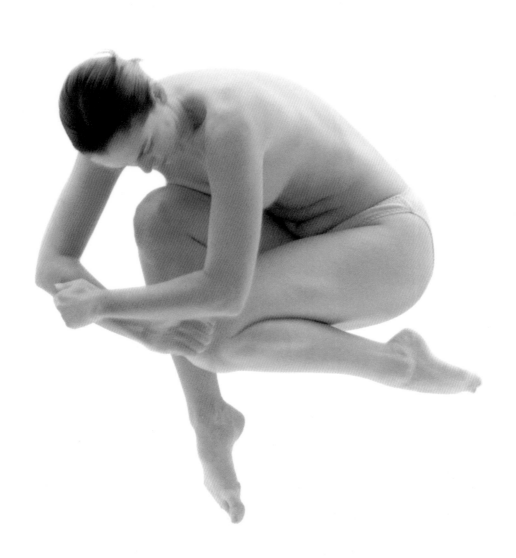

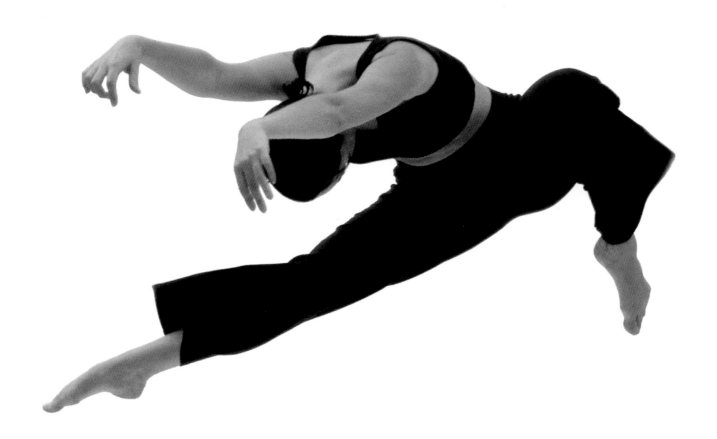

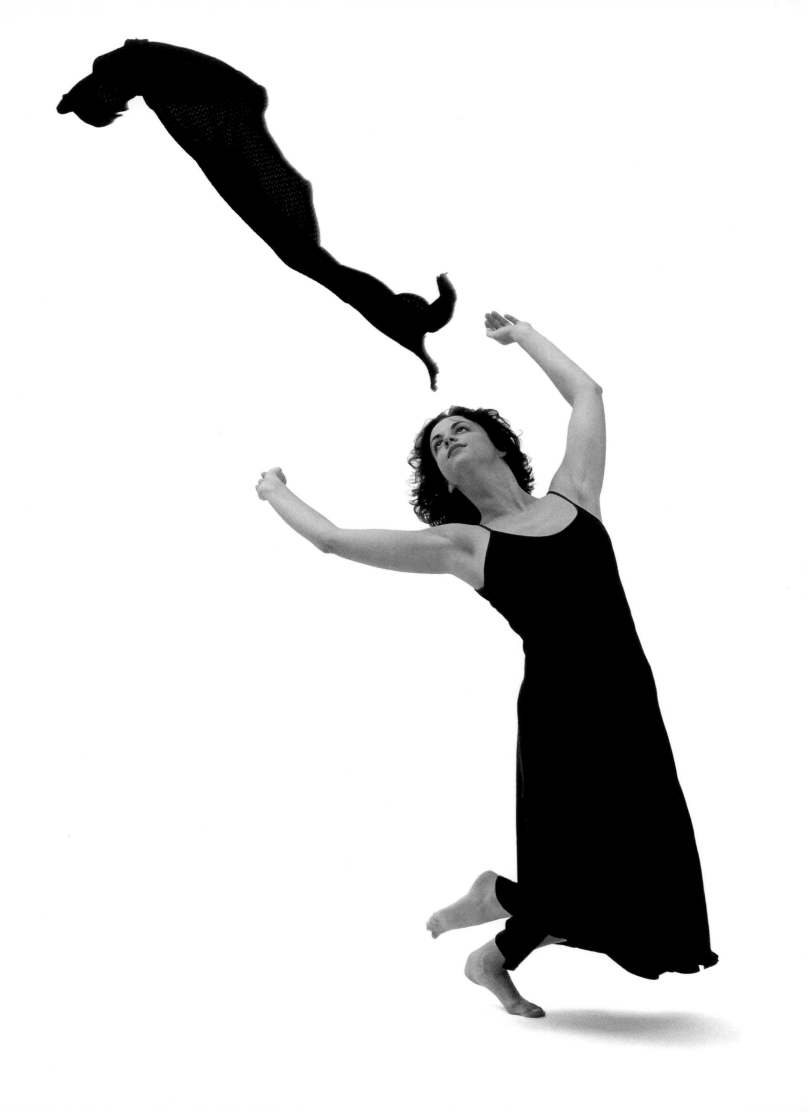

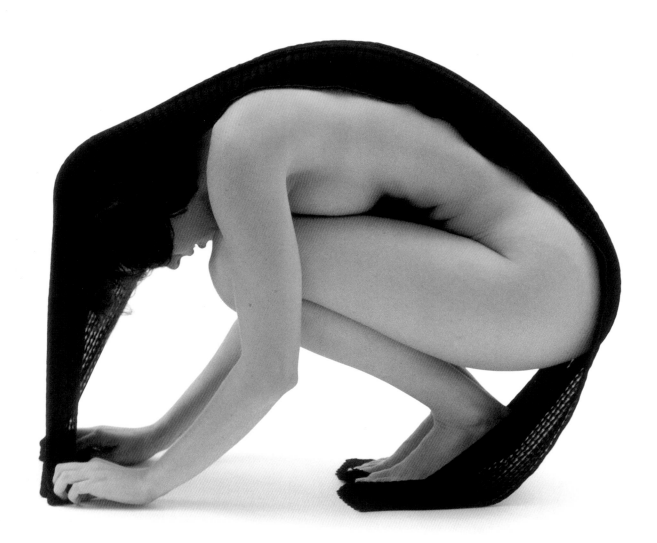

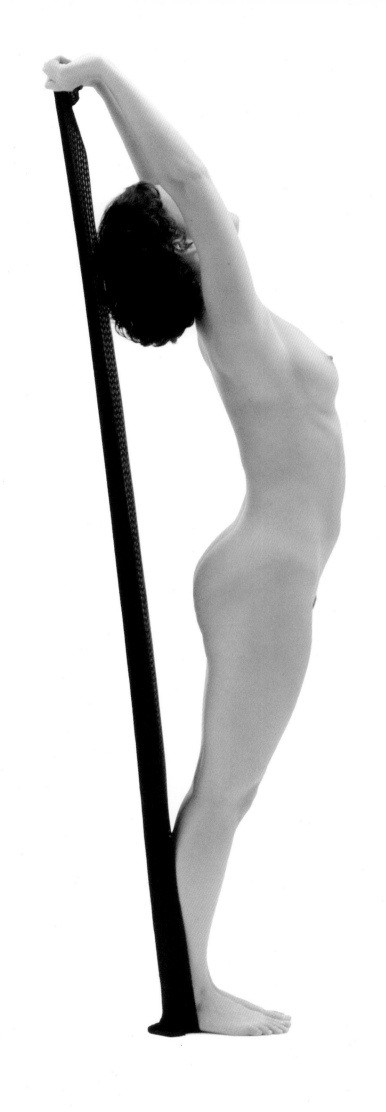

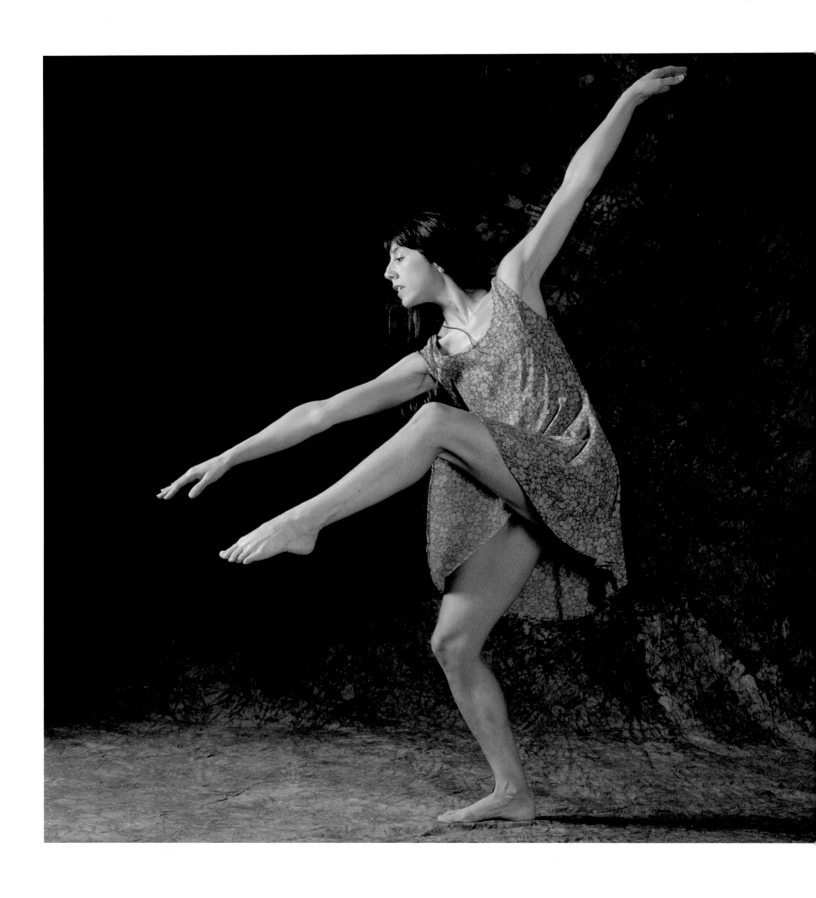

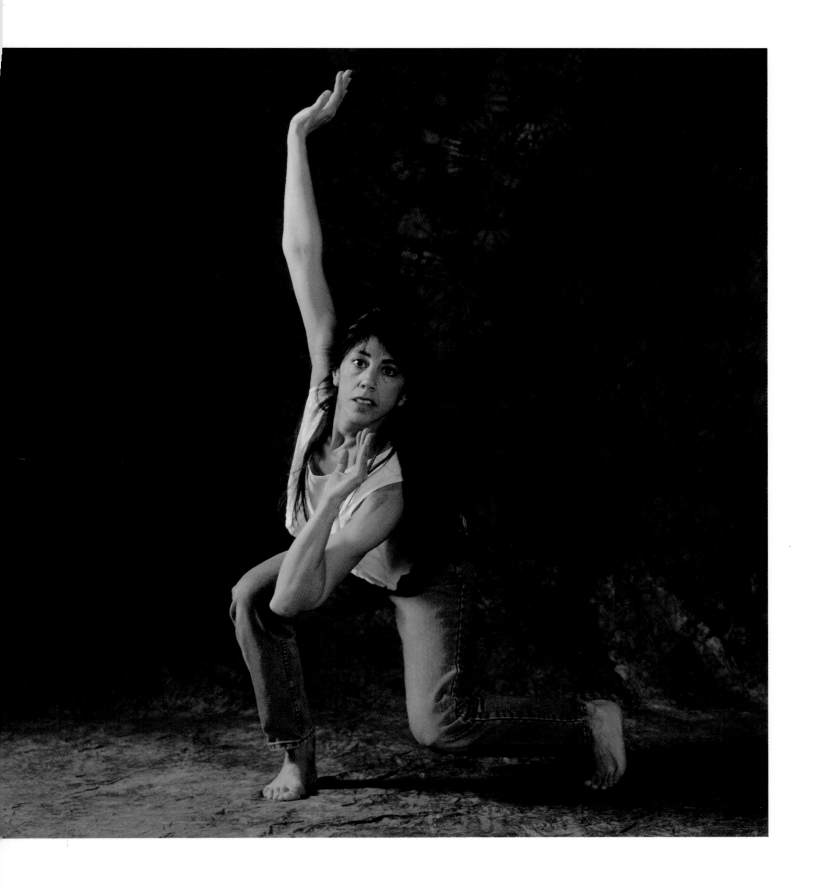

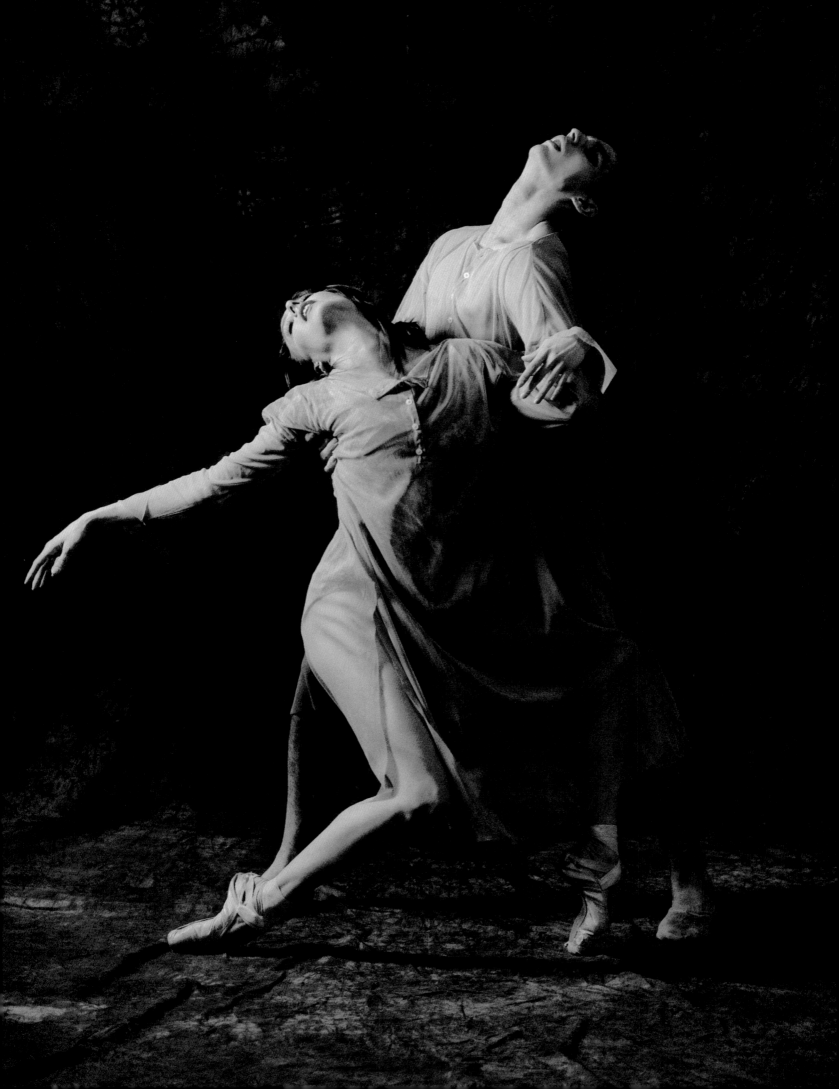

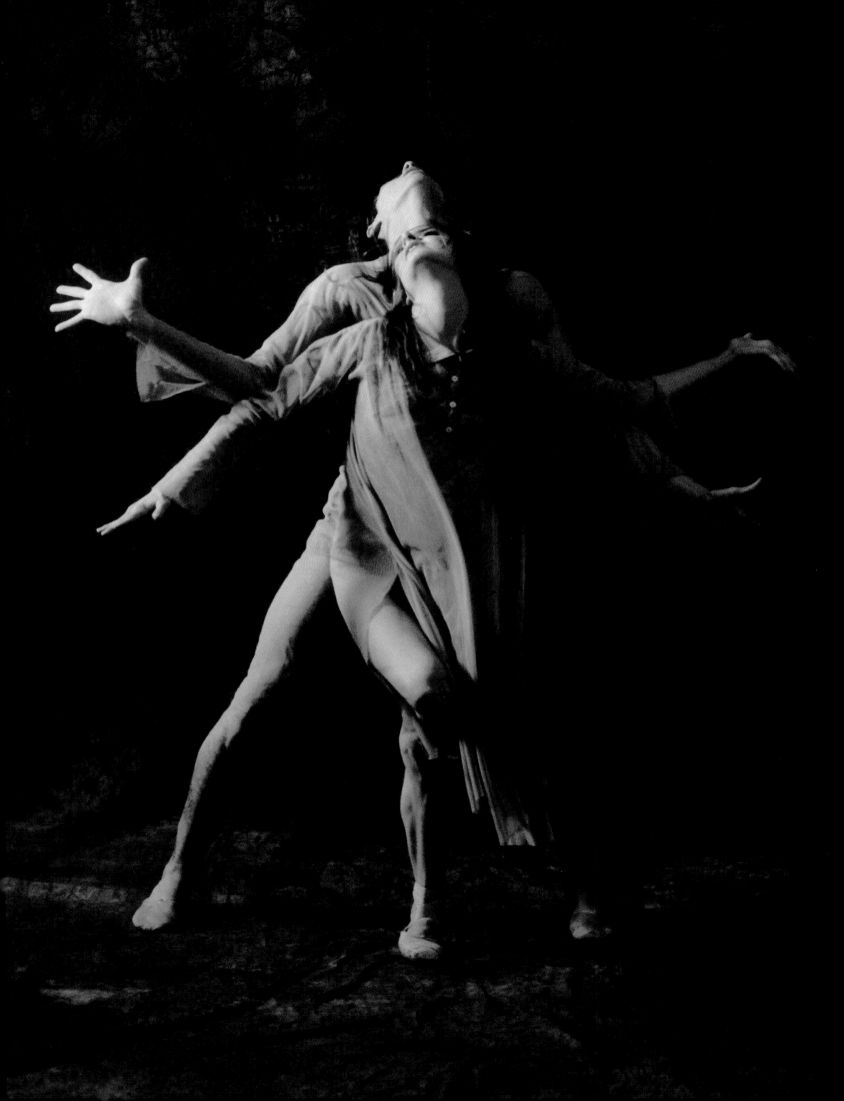

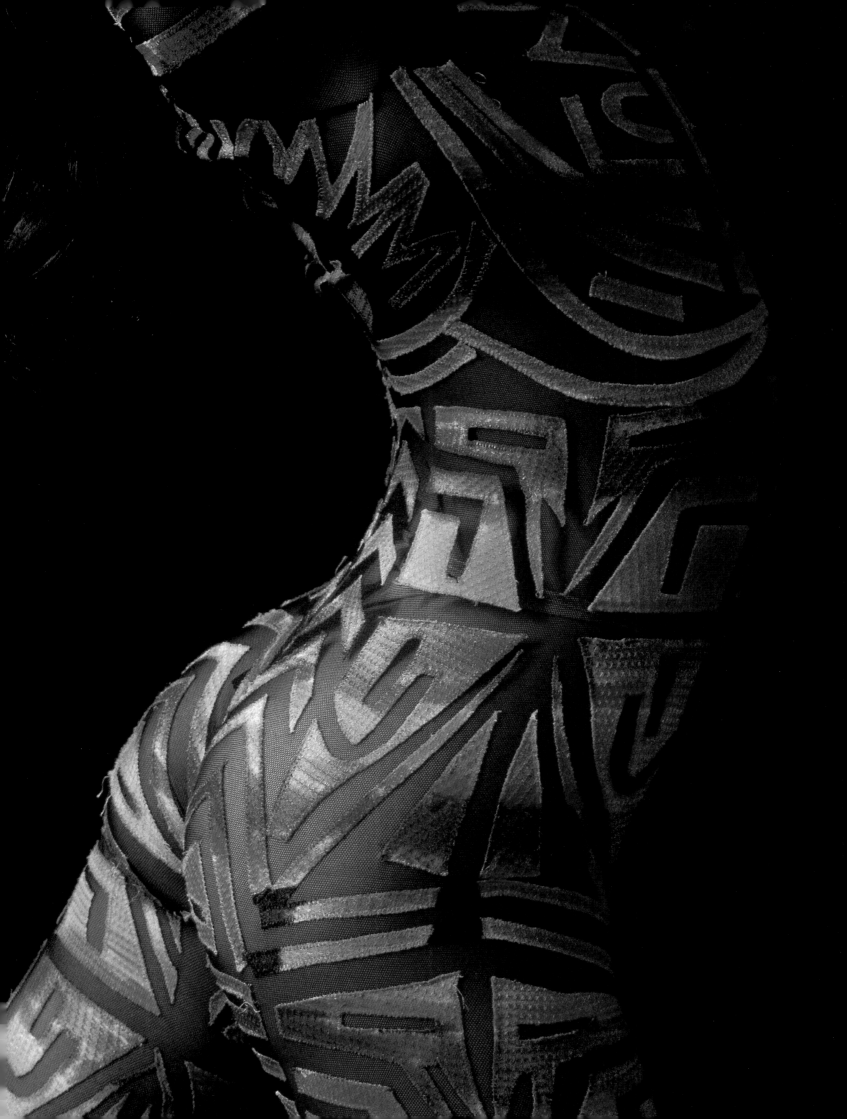

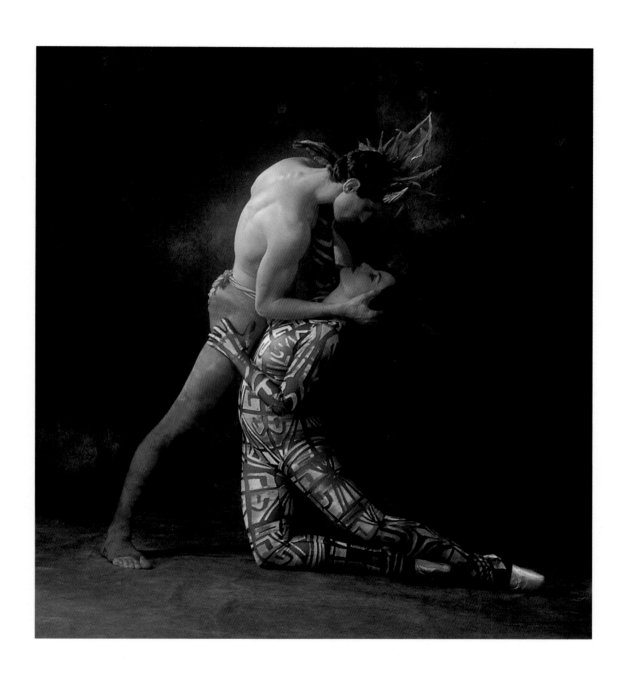

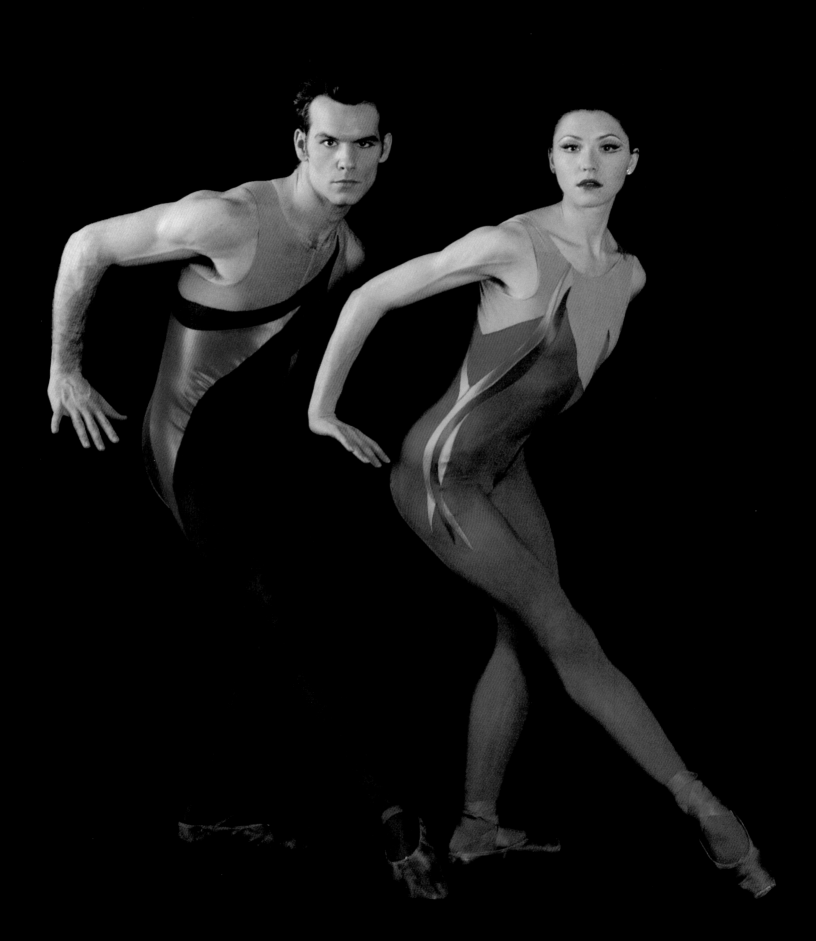

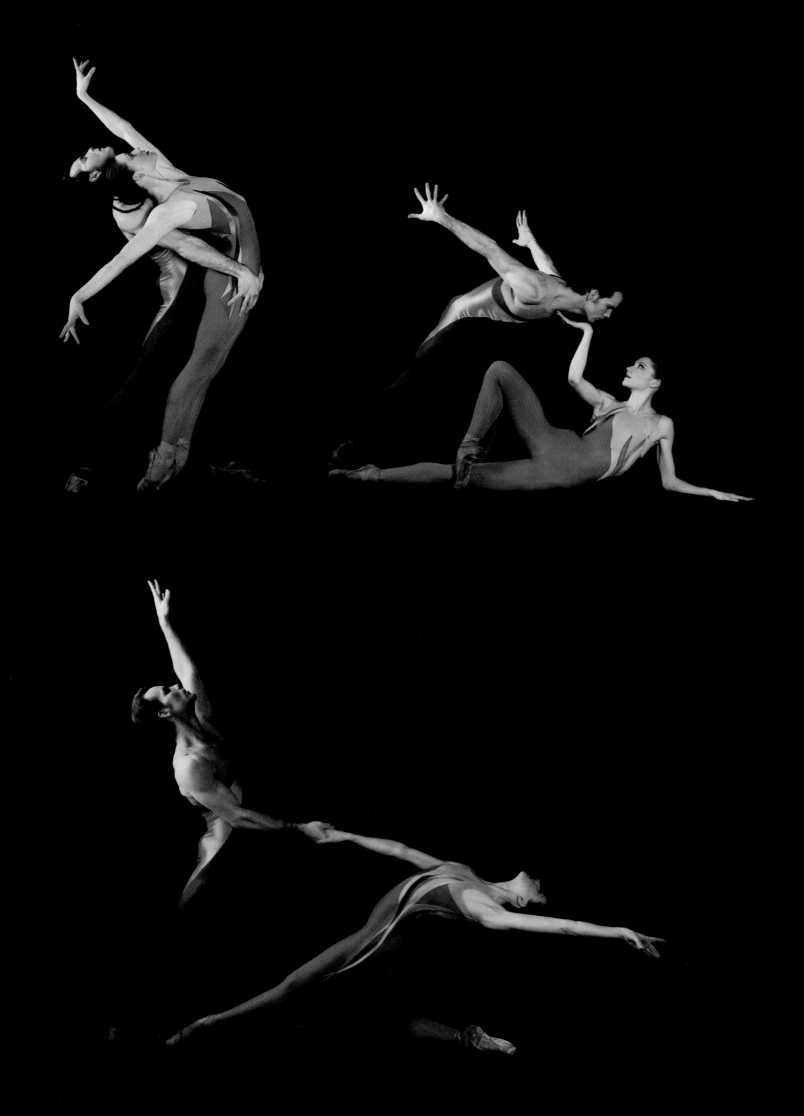

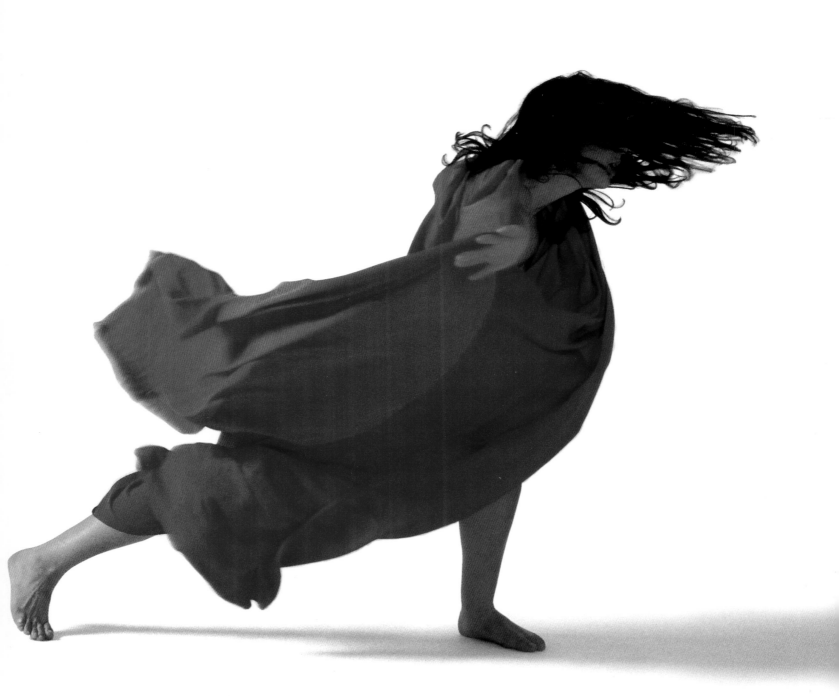

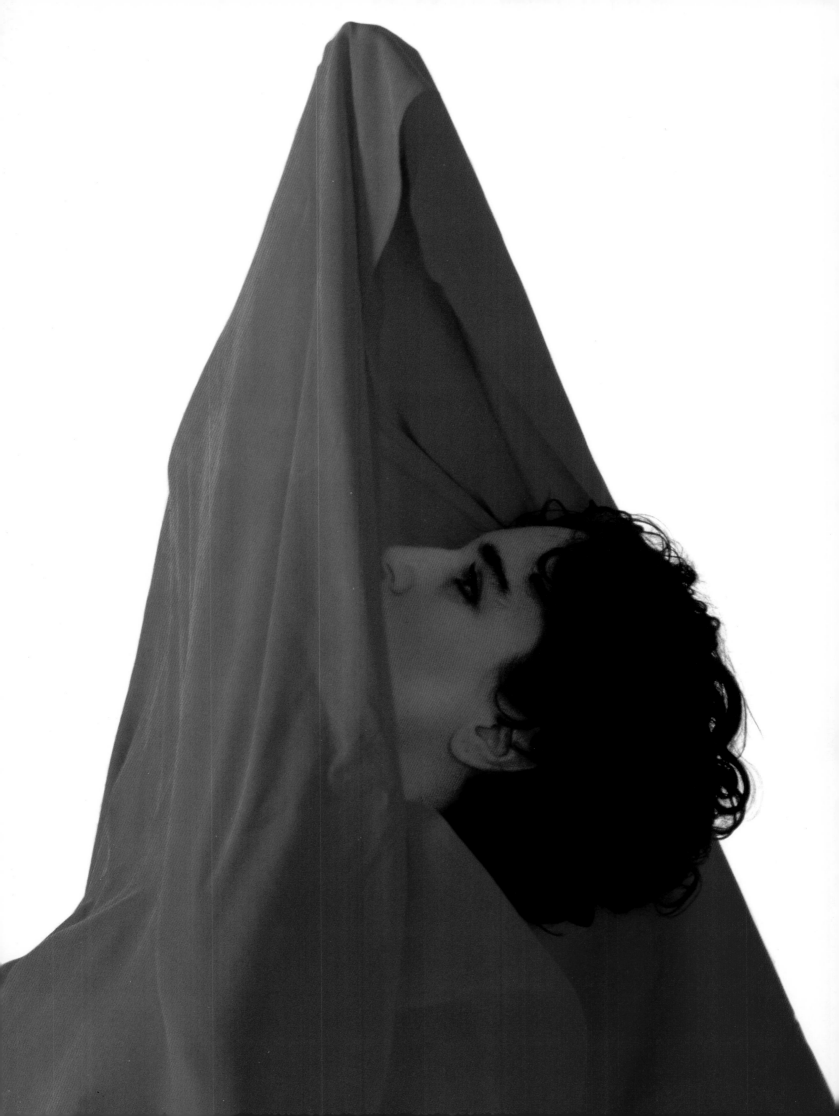

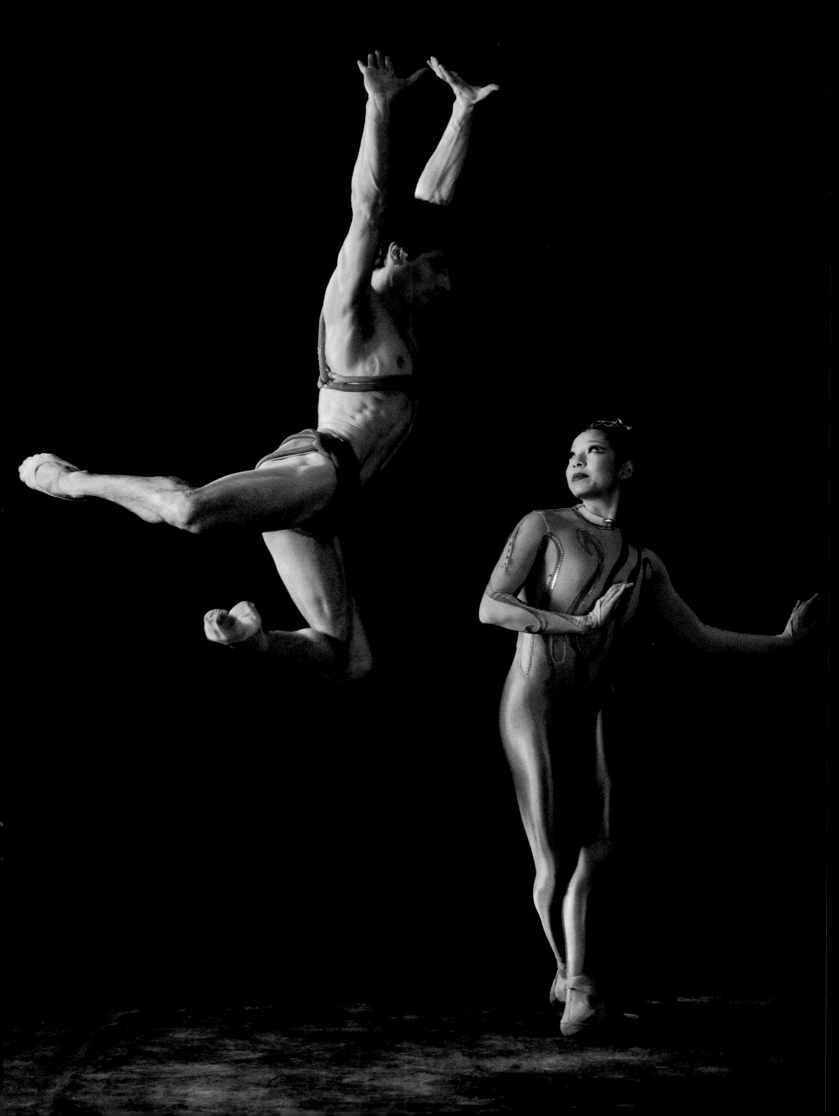

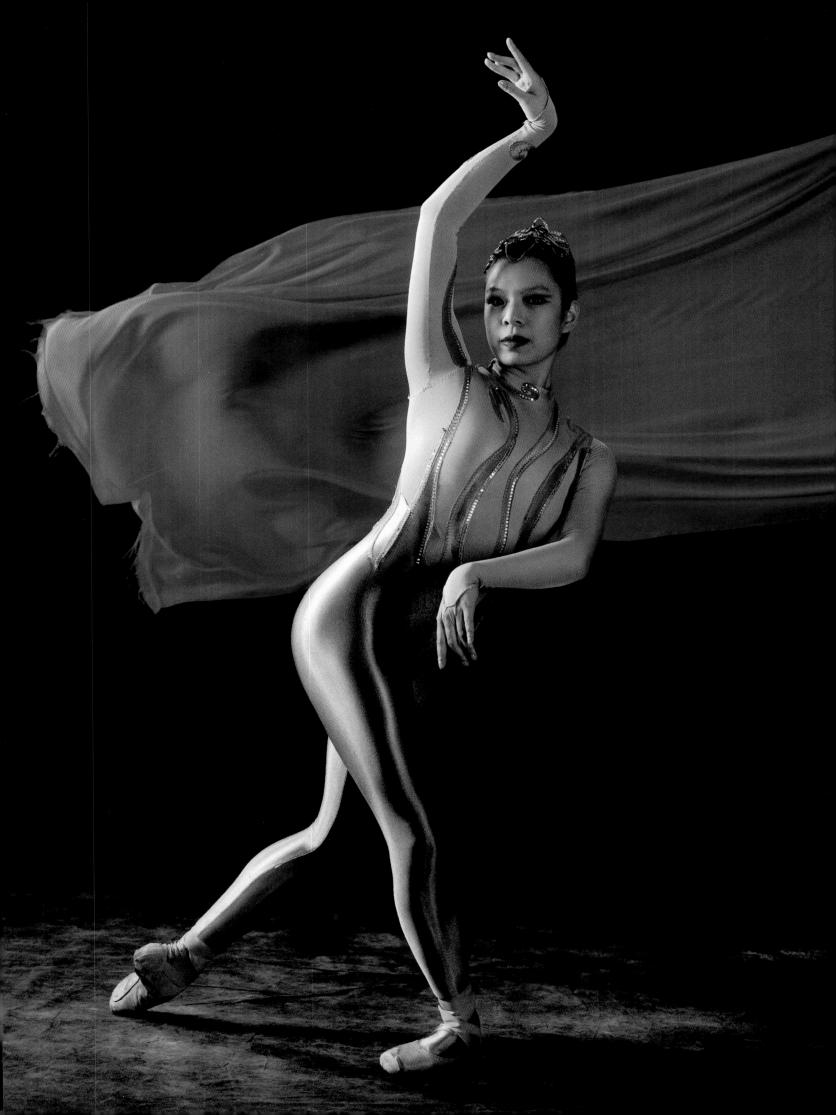

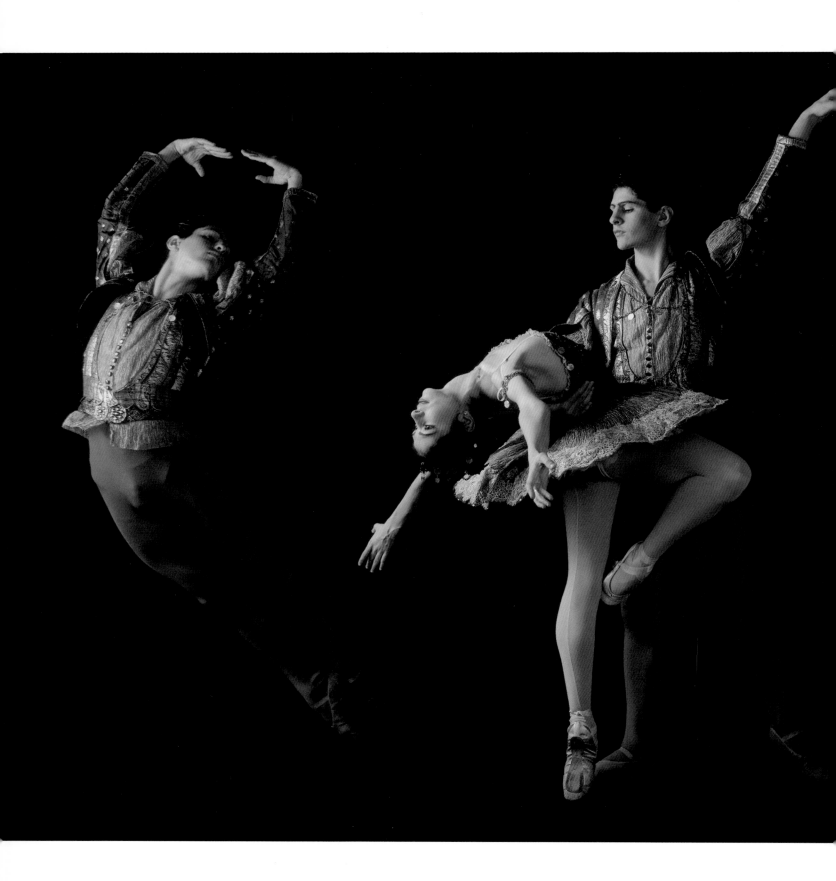

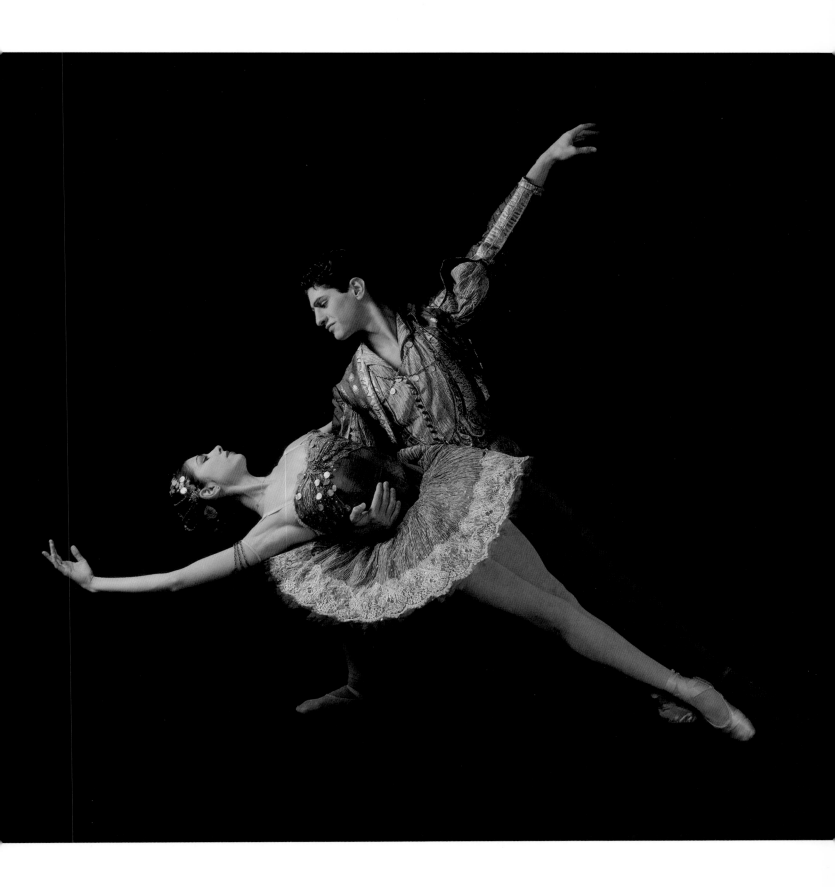

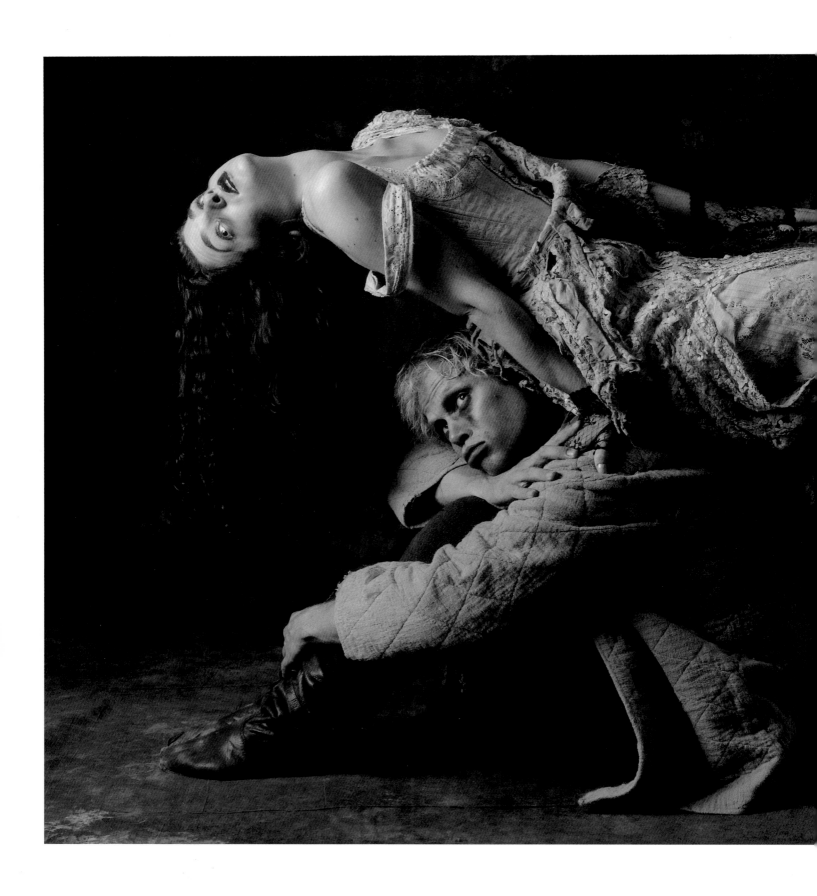

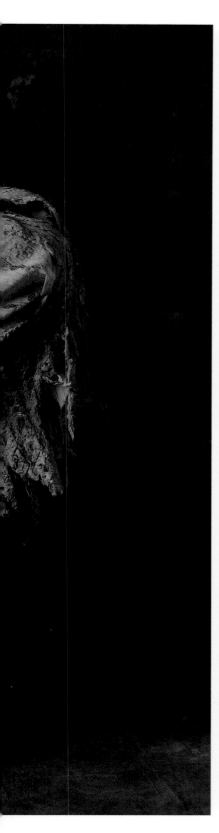

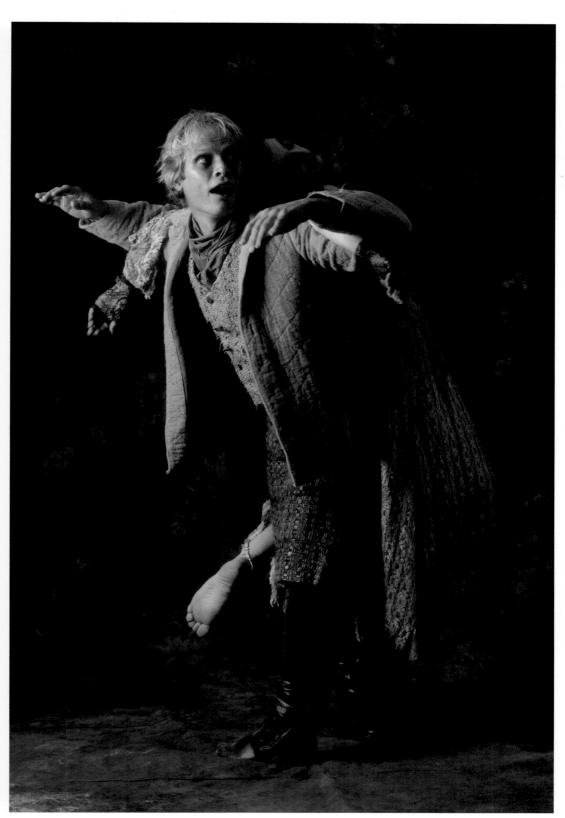

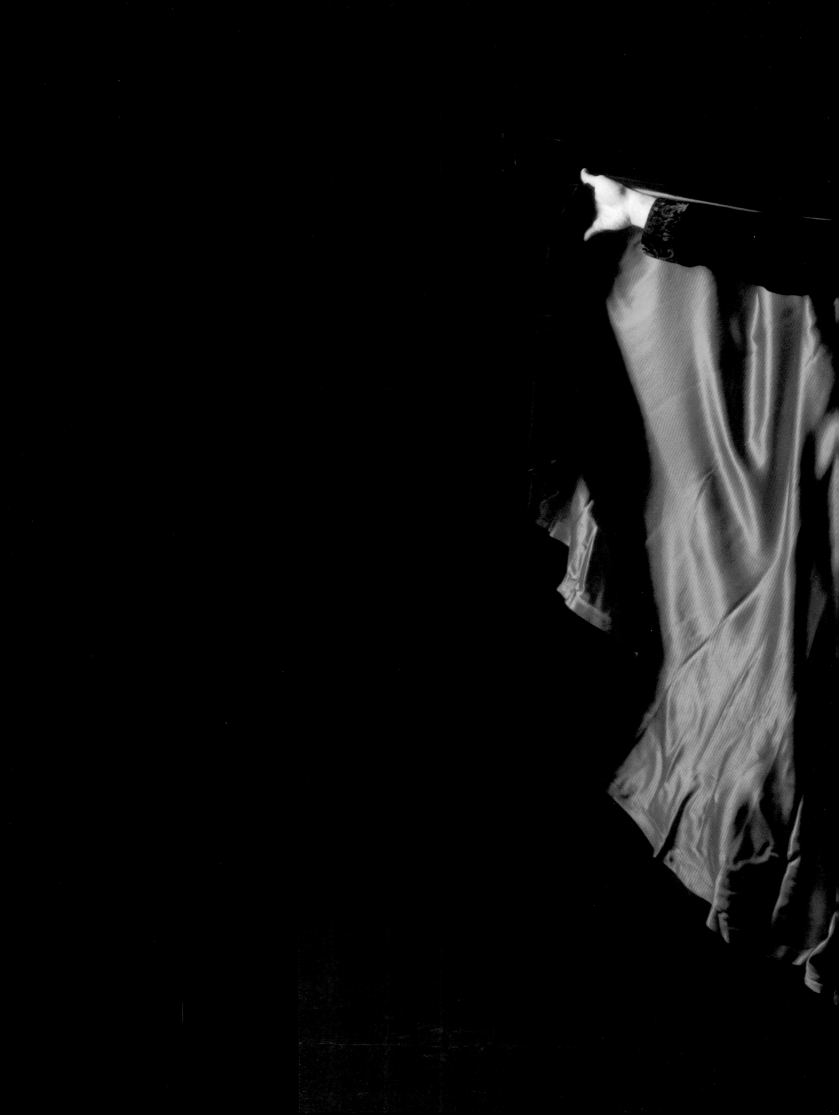

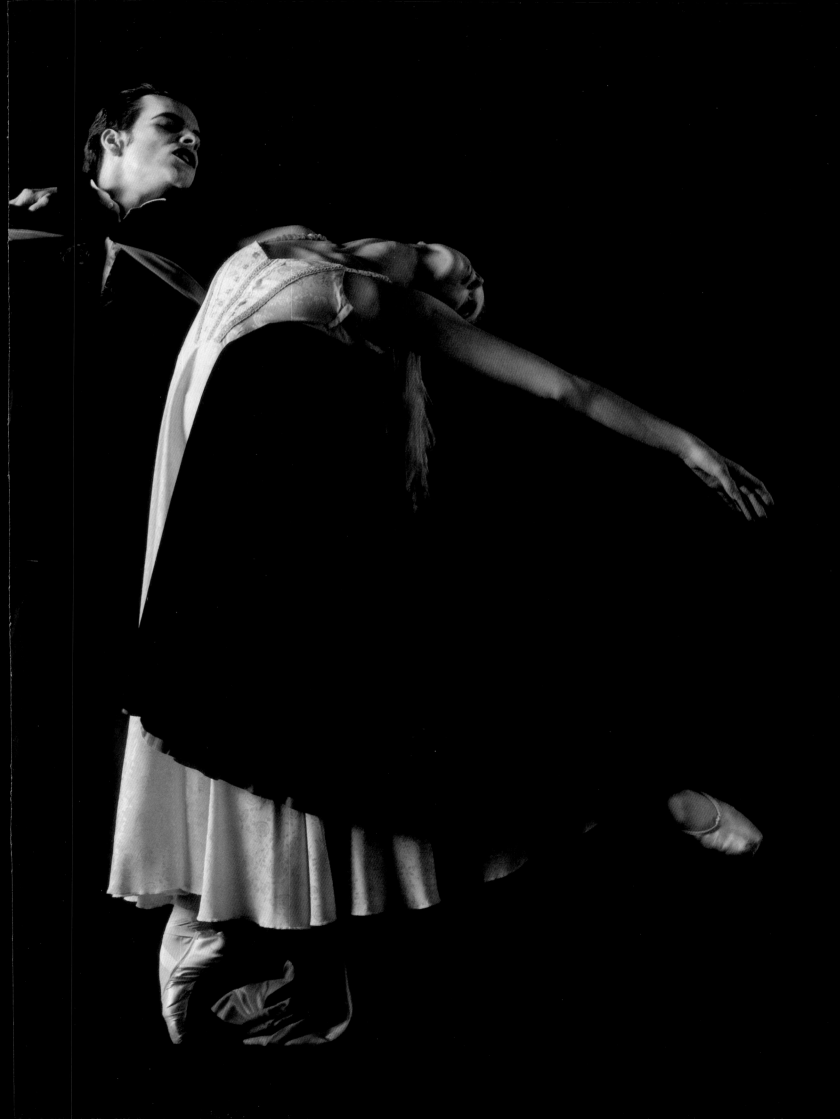

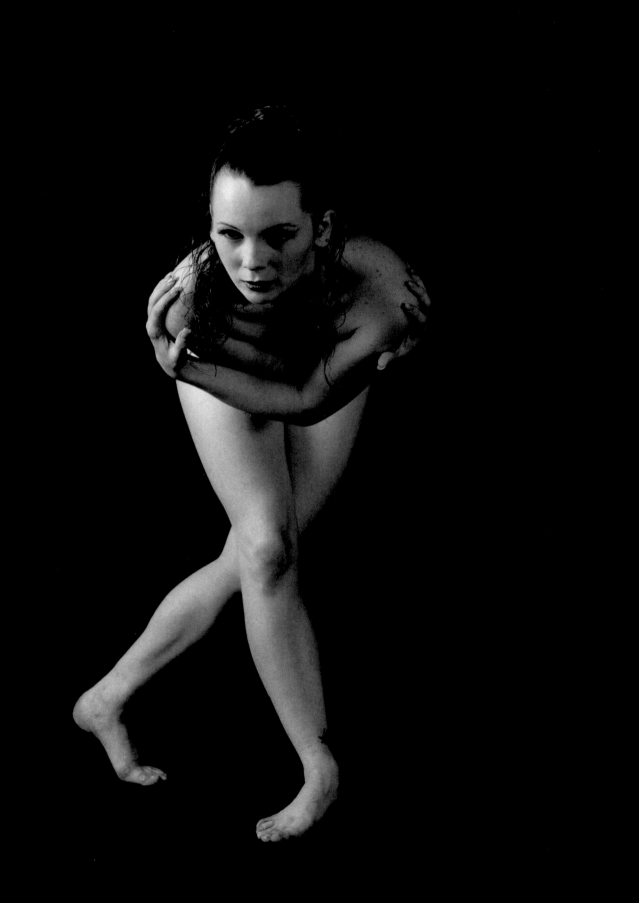

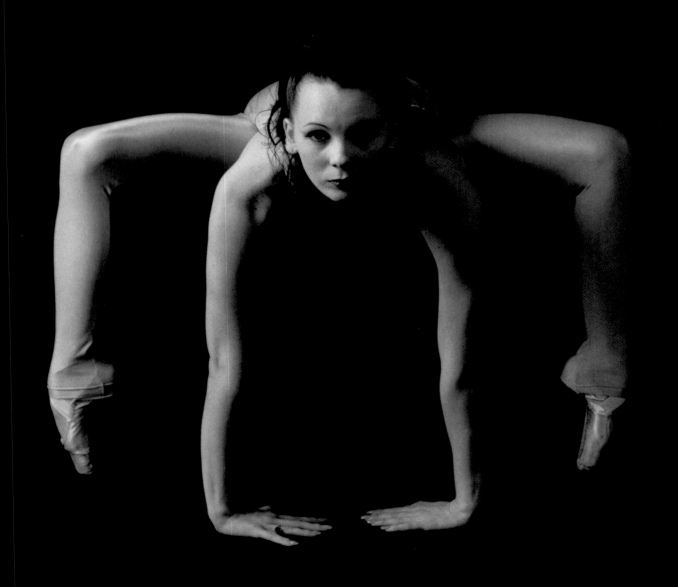

Dance is a song
of the body.
Either of joy or pain.

—Martha Graham

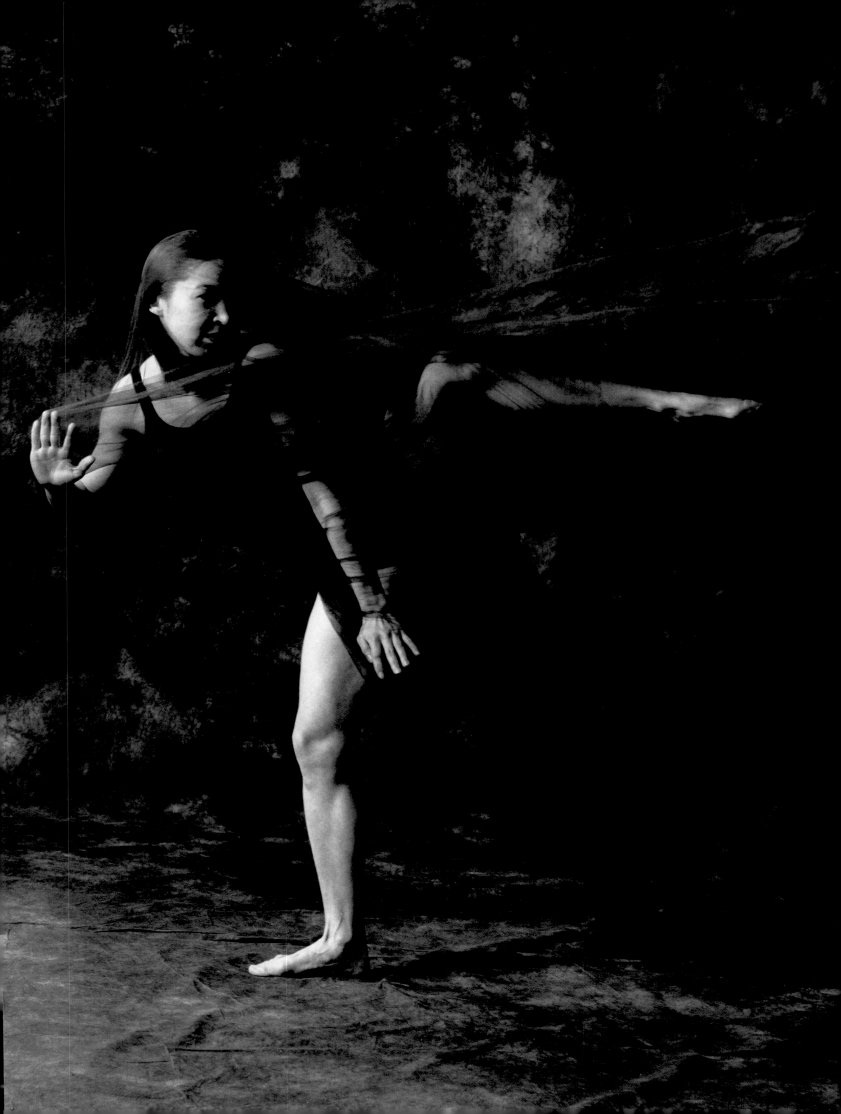

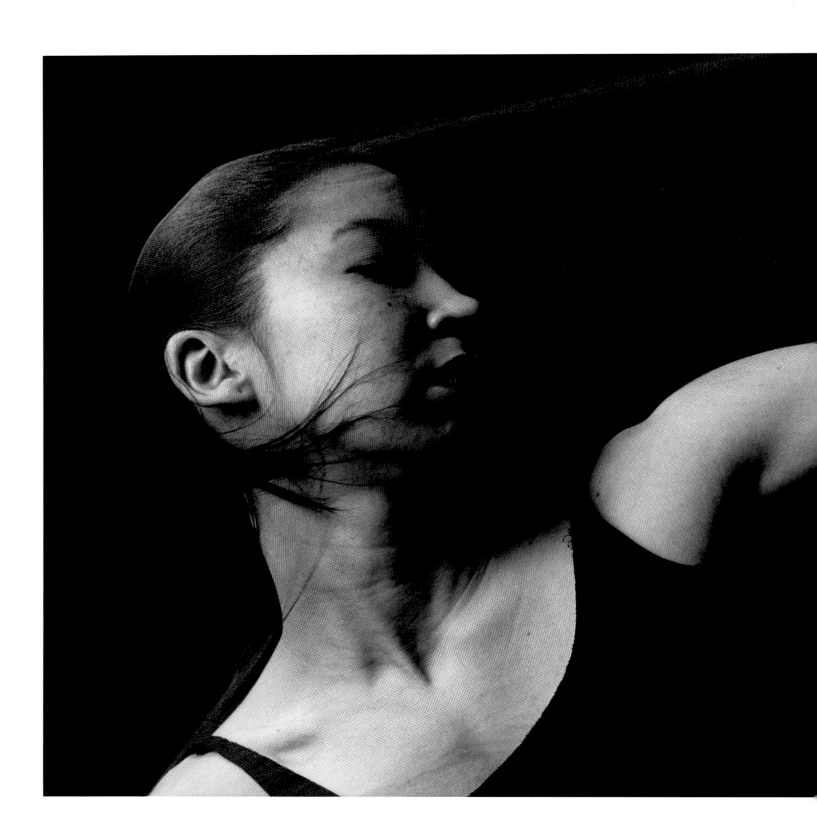

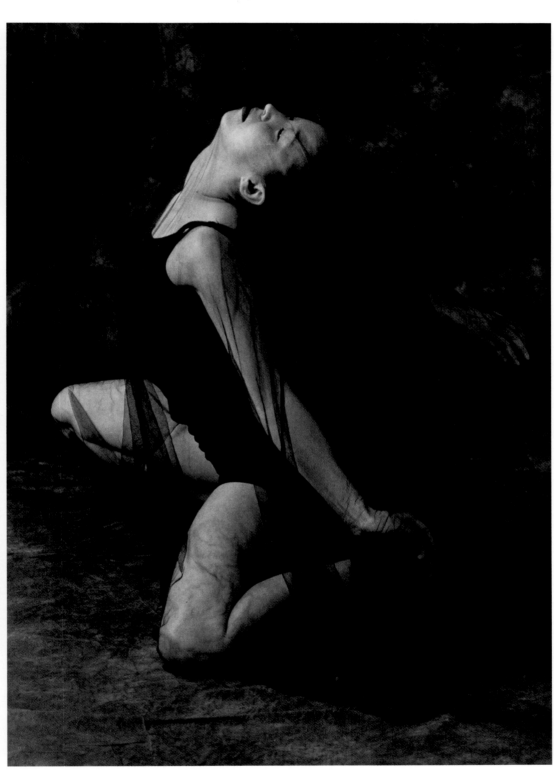

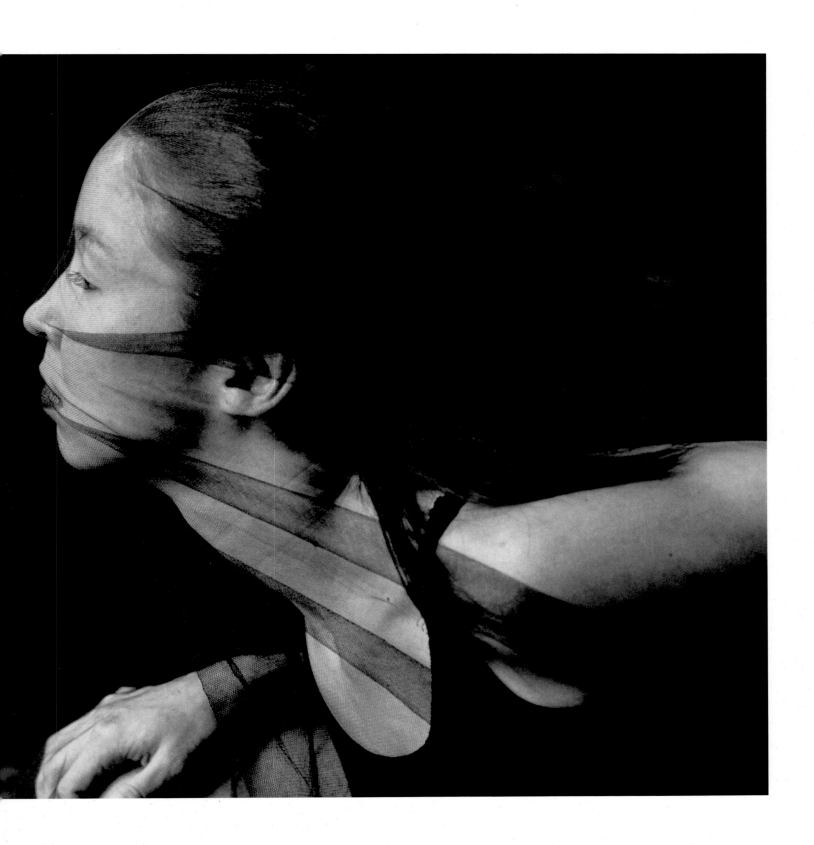

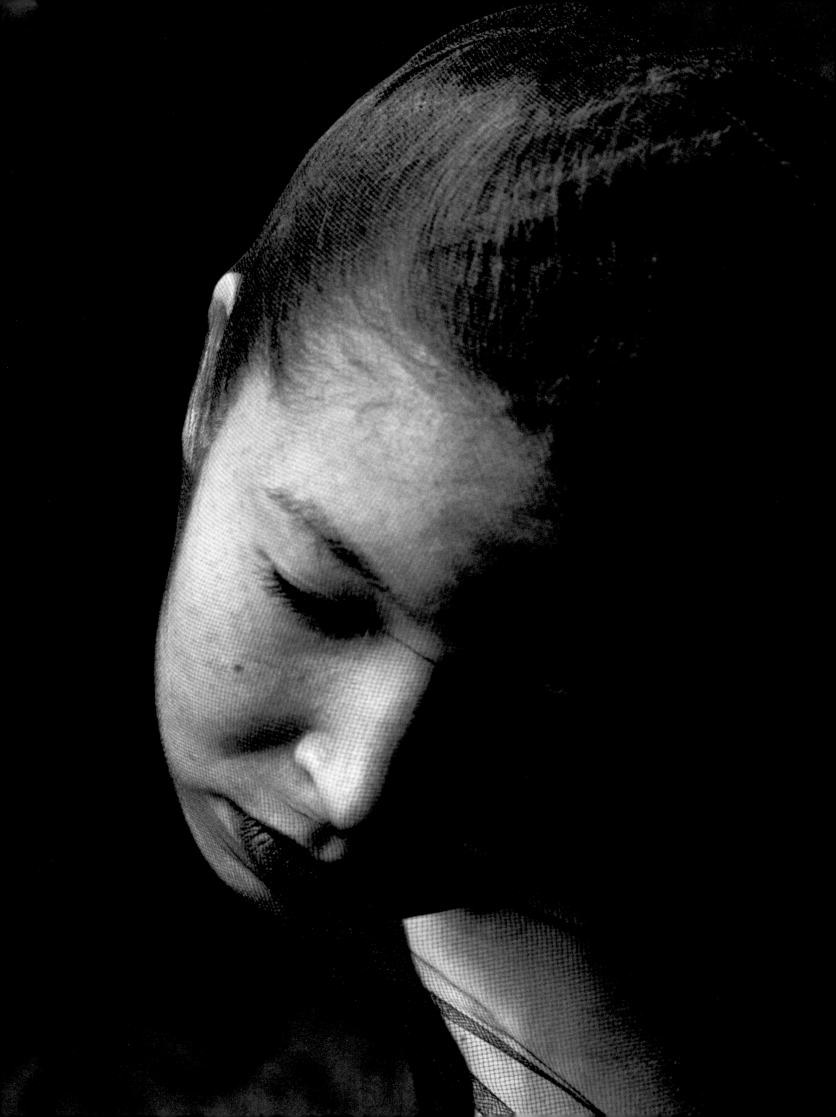

THE BOOK'S PERFORMANCE RALPH GIBSON

Both the dance and the book as forms are entirely dependent on their audiences. Viewers experience both through time, and the reality of both media is not their physical existence per se, but in the response they elicit from their audiences. Likewise, the reality of the dance is never just the motion of the dancers; yet so often photography tries to replicate or comment only upon that motion. The best photographs of the dance do considerably more—they evoke the same emotional response from their viewers as the dancers did from their audience while performing. In a successful dance book, a certain alchemy allows the photographs to transcend the mere event of their subject matter.

I know very little about the dance other than what it feels like to sit in the audience and observe. As with so many other significant acts, I only seem to understand the dance during the moment it transpires. The minute it is over, all I have is the memory of something I like, but don't fully understand—I can barely recall the feeling. These photographs help me recall. They are able to do so because the photographer has managed to make himself transparent: he has not imposed himself between the dancers and the lens. The emotion the dancers created has been projected directly

onto the film, and those pictures have been organized into this book, a book that places its audience back in the emotion of the performance.

Dance itself is about the division of a fixed space—which usually has the dimensions of a stage—through motion. Like the stage, the book is also a creative space, a distinct atmosphere. A book has a title, a size, a way of presenting the photographs—in this book, the bleeds emphasize the sense of motion. Like stages, books have a fixed viewing distance, give or take a few rows or inches. People neither go to the dance nor look at books unless they want to. In its sequencing and graphic presentation, a book is its own dramatic performance, with an intrinsic rhythm, a narrative perhaps, and certainly an emotional content or journey.

A book, however, allows the viewer to pause and study a particular moment. Looking at this book, one is able to consider the difference between a rehearsal in the corner of a studio and a well-lit, fully costumed spectacle— virtually light-years of intention removed. Particularly intriguing is the implication of the nude rehearsal (see pages 56–57). This is a solitary event in which the photographer was incidental. Yet the fact that it was photographed allows us to feel the effort and concentration of the performer.

Ultimately, the success of dance photography all depends on what the dance photographer thinks dance is; a series of static poses, the beauty of the body, or the spectacle of theater. Here we have highly energized bodies against positive or negative fields. Nothing else. No sets, no tricks. It is clear that Ron thinks dance is about the self-expression of the dancers. But to what extent does a dancer externalize his or her emotions? Dancers must give themselves up without a shadow of a doubt to a higher calling. They are keeping our amorphous need for pure art afloat. This passion is a part of what runs through all of their movements, and it must be this that Ron is drawn to.

I love anything done well in photography, which usually implies that it must be emphatically authentic. Ron has both a life-long love of the performing arts and decades of understanding behind him of how photography works. Yet his relationship to the medium has been completely suborned by the content of the images. The photographs in this book are about virtuosity and the chemistry of the shoot. Ron can make such images because he clearly has an instinctive, visceral relationship to the dance; a relationship that is made visible in the form of these photographs.

DANCERS

Jacket: Nicole Sistare

Front cover: Maria Brown

Back cover: Danielle Genest

All photographs were made between
1992 and 1998.

ACKNOWLEDGMENTS

There are so many people to thank!

Especially Kirk Peterson, former Artistic Director of the Hartford Ballet, and a wonderful choreographer. He built a first-class company of very talented dancers and gave me virtually unlimited access to them and support for my work.

Michael Uhtoff, founder, and also a former Artistic Director of the Hartford Ballet. He helped me enormously as I learned something about how to photograph dance.

Enid Lynn, who runs the Hartford School of Ballet, and is now Co-Artistic Director of Hartford Ballet, was the first to encourage my interest and made her classes available to me to photograph.

Judy Dworin, Professor and Chair of the Theater and Dance Department at Trinity College, Hartford and Artistic Director of Judy Dworin Performance Ensemble; and Laura Glenn, Artistic Director of Laura Glenn / Works. Both are first rate choreographers and directors of modern dance companies. They have given me much support and encouragement.

While the images in this book are all "studio portraits" (that is, none of them were shot during rehearsal or performance) I have been excited by the works of many choreographers, including Graham Lustig, Monica Levy, Jean Grand-Maitre, and Choo-San Goh, whose works are so ably staged by Janek Schergen. Their works in particular have moved and inspired me.

I have been fortunate to have had two great photographers as mentors: Ralph Gibson and Ian Shaw. Ralph's critiques, comments, discussions, and example have inspired and informed me. He has invited me to work with him from time to time, and those experiences have been seminal—and wonderful fun. Ian is based in London, and works all over Europe and in the U.S. For fifteen years or more I have counted on Ian, during my many trips to London, for very helpful comments and advice on my work. He is a great picker of pubs too.

This book would not have been possible without the total support of Aperture. Michael Hoffman, Aperture's Executive Director, has encouraged me for years to think about a book. Melissa Harris, Aperture's Senior Editor, has reviewed my dance work almost from the beginning, and her comments and suggested direction have been right on the mark.

I can not imagine a better editor than Phyllis Thompson Reid— thoughtful, understanding, imaginative, encouraging. She and Michelle Dunn, a gifted designer whose layout of the book was impressive from the start, have been both exciting and fun to work with. I would also like to thank Martin Senn for his exquisite tri-tone film work.

Marc Sitkin's Primary Color Lab in Hartford has printed my color for years, including the images for this book. The quality of their work is unsurpassed.

I owe special thanks to Dalmation Black and White Custom Lab of Greensboro, North Carolina, and its owners, Pamela Crist and Katherine Watlington, who somehow found the time to print the black-and-white prints for this book, beautifully, at the eleventh hour because I was recovering from emergency eye surgery, and couldn't do it myself.

Library of Congress Catalog Card Number: 99-61681
Hardcover ISBN: 0-89381-873-9

Book design by Michelle M. Dunn
Jacket design by Peter Bradford and Joshua Passe

Printed and bound by Musumeci Printing, Aosta, Italy

The Staff at Aperture for *Stillpoint* is:
Michael E. Hoffman, *Executive Director*
Phyllis Thompson Reid, *Editor*
Stevan A. Baron, *Production Director*
Eileen Max, *Associate Production Director*
Lesley A. Martin, *Managing Editor*
Rebecca Kandel, *Editorial Work-Scholar*
Jorge Del Olmo, *Production Work-Scholar*

Aperture Foundation publishes a periodical, books, and portfolios of fine photography to communicate with serious photographers and creative people everywhere. A complete catalog is available upon request. Address: 20 East 23rd Street, New York, New York 10010. Phone: (518) 789-9003. Fax (518) 789-3394. Toll-free: (800) 929-2323. Visit Aperture's website: http://www.aperture.org

Aperture Foundation books are distributed internationally through:
CANADA: General/Irwin Publishing Co., Ltd., 325 Humber College Blvd., Etobicoke, Ontario, M9W 7C3. Fax: (416) 213-1917. UNITED KINGDOM, SCANDINAVIA, AND CONTINENTAL EUROPE: Robert Hale, Ltd., Clerkenwell House, 45-47 Clerkenwell Green, London, United Kingdom EC1R OHT. Fax: (44) 171-490-4958. NETHERLANDS, BELGIUM, LUXEMBURG: Nilsson & Lamm, BV, Pampuslaan 212-214, P.O. Box 195, 1382 JS Weesp. Fax: (31) 29-441-5054. AUSTRALIA: Tower Books Pty. Ltd. Unit 9/19 Rodborough Road, Frenchs Forest, New South Wales, Sydney, Australia. Fax: (61) 2-9975-5599. NEW ZEALAND: Southern Publishers Group, 22 Burleigh Street, Grafton, Auckland, New Zealand. Fax: (64) 9-309-6170. INDIA: TBI Publishers, 46, Housing Project, South Extension Part-I, New Delhi 110049, India. Fax: (91) 11-461-0576.

For international magazine subscription orders for the periodical *Aperture*, contact Aperture International Subscription Service, P.O. Box 14, Harold Hill, Romford, RM3 8EQ, United Kingdom. One year: $50.00. Price subject to change.

To subscribe to the periodical *Aperture* in the U.S.A. write Aperture, P.O. Box 3000, Denville, New Jersey 07834. Toll-free: (800) 783-4903. One year: $40.00. Two years: $66.00.

First edition
10 9 8 7 6 5 4 3 2 1